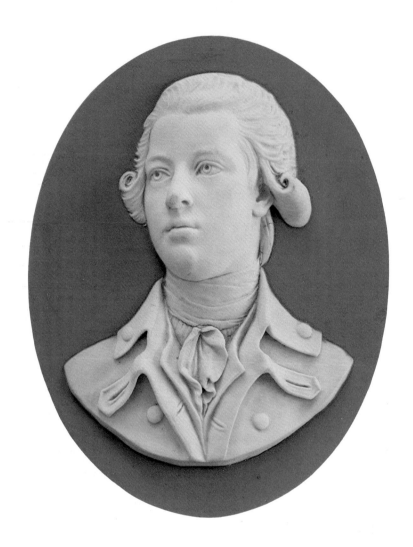

William PITT (The Younger), 1759-1806
Blue dip. $3\frac{5}{8}$ in. WEDGWOOD
Attributed to John Flaxman Jnr. about 1787
Wedgwood Museum, Barlaston

Wedgwood Portrait Medallions

Robin Reilly

National Portrait Gallery

During the last quarter of the eighteenth century the passion of the British for portraiture amounted almost to frenzy. Likenesses of the great, of family and friends, were demanded and provided in a variety of media as wide as it was extraordinary. Portraits in oils; miniatures in watercolour on ivory; life-size figures and busts in marble or bronze; small busts in relief, carved, modelled, or cast in ivory, wax, glass paste, jasper, and basaltes; profiles cut out or painted in silhouette; bronze medallions; even needlework portraits worked in the sitter's own hair; all illustrate a fashion never equalled in any country. This is all the more surprising considered in relation to the slow growth of portraiture in Britain. There is little which could be described as portraiture in the modern sense before Occleve's Chaucer, a posthumous portrait 'to remind other men of his personal appearance', and nothing much of significance before Holbein's introduction to the court of Henry VIII in the early 1530s.

The first Elizabethan age curiously lacked any native painter to develop Holbein's realism in the full-scale portrait, but Nicholas Hilliard's jewel-like miniatures introduced a new dimension, intimate and private, to an art formerly shared as furniture. During the seventeenth century, portraiture in Britain was dominated by Dutch and Flemish immigrants. Mytens, Van Dyck, Kneller, and Lely exerted an influence which extended to the miniaturists of the period with generally inhibiting effect. Van Dyck and Lely were knighted, and Kneller received a baronetcy, but portrait painting was, nevertheless, not recognized as a socially acceptable activity and the Earl of Shaftesbury described it in 1712 as 'an abuse of real art'. In the eighteenth century, this opinion was eroded by Hogarth and finally destroyed by Reynolds and Gainsborough. With the development of a truly British school of portraiture and a revitalized school of miniaturists, there emerged a remarkable public interest in historical portraits epitomized by the 'Grangerising' of standard works of history.

It is not easy to account for the fashion which so engaged eighteenth-century Britain. The memoirs of the period are studded with references to portraits, bearing witness to a mania widespread through all but the class of society unable to afford it. The influences which brought this about were as disparate as the classical revival following the excavations at Herculaneum and Pompeii, the improvement in communications and consequent appreciation and recognition of public heroes, and the opportunities for social advancement inherent in the industrial revolution and the desire of the prosperous middle class to equip their houses in the manner of the aristocracy. These influences combined to create a feeling for the importance of the individual, a celebration of the family, and a reverence for history. It was the great age of monuments and of the desire for personal, visible, and lasting memorials.

Josiah Wedgwood was one of those to whom industry brought opportunity. Born in 1730, the youngest child in a large family of third-generation craftsman potters, he received only three years' formal education before the death of his father obliged him to go to work. He was employed by his eldest brother for five years before being officially apprenticed to him, at the age of fourteen, to learn 'the Art, Mistery, Occupation or Imployment of throwing and Handleing'. He was handicapped by an infection in one knee, thought to have been 'Bridie's Abscess' resulting from an earlier attack of smallpox, which subsequently caused him to have the leg amputated under the supervision of his friend, Dr. Erasmus Darwin. In 1752, after thirteen years of employment, the young Josiah was refused a partnership in his brother's pot-bank and he left to join John Harrison. Two years later he was taken into partnership by Thomas Whieldon, the most creative potter in Britain, at Fenton Vivian.

Whieldon's influence on Wedgwood has yet to be examined fully, but there can be no doubt that it was vital to Wedgwood's early development. Whieldon's white

stoneware, and the experimental tortoise-shell wares decorated in random streaked patterns formed by the fusing into the glaze of powdered metal oxides dusted over the surface before firing, inspired Wedgwood 'to try for some more solid improvements as well in the Body as in the Glazes, the Colours, and the Forms, of the articles of our manufacture'. Whieldon generously allowed his new partner ample opportunity and material for experiments, and appears, even more generously, to have allowed the fruits of these experiments to remain Wedgwood's sole property. Recent research indicates that in addition to green and yellow glazes used mainly for 'cauliflower wares', experiments towards the improvement of the black stoneware then known as 'Egyptian black' and also in the production of a cream-coloured earthenware body were carried out at the Whieldon factory.

In 1759 Wedgwood was ready to move on to start his own pottery at the Ivy House, and three years later he moved to the Brick House, later known as the Bell Works, where he manufactured 'useful wares' for the following eleven years. During this period he perfected his rich deep green glaze, used to decorate earthenware in imitation of the fashionable cabbage, cauliflower, and pineapple shapes produced in soft paste porcelain at Chelsea, following the Meissen porcelain of the Baroque period: developed a fine-grained black stoneware, infinitely superior to the coarse Egyptian black of other Staffordshire potteries, which he named Basaltes; improved and refined the crystalline wares in imitation of agate, porphyry, and other variegated natural stones; and created an original cream-coloured earthenware body. The latter he described as 'a species of earthenware for the table, quite new in appearance, covered with a rich and brilliant glaze, bearing sudden alterations of heat and cold, manufactured with ease and expedition, and consequently cheap'. He studied the form and design of contemporary porcelain and silver and adapted them for the softer lines of earthenware, producing a range of tableware at once cheap enough for all but the poorest families and elegant enough to be desired by royalty. It was incomparably his greatest contribution to the industry and to society, and exerted an influence in Europe beyond that of any of the productions of Meissen or Sèvres.

Much of Wedgwood's earliest decoration on creamware was transfer printed, and it was on one of his visits to the printers, subsequently Sadler & Green, in Liverpool that he met Thomas Bentley, a prosperous merchant who was, seven years later, to become his partner. Bentley was a man of education and taste, and his social contacts and knowledge of the arts were of inestimable value to Wedgwood. The articles of partnership were signed in 1769, and in the same year Wedgwood opened a new factory, which he named Etruria, on the Ridge House estate between Hanley and New-castle-under-Lyme. Bentley's special responsibility was for the 'ornamental wares'—broadly those pieces not designed for use at the table—and for the organization of the London showroom, but he was also active in obtaining introductions to wealthy and influential patrons and in finding artists and modellers to work for Wedgwood either at Etruria or, on commission, in London.

In 1773 Wedgwood published his first catalogue of ornamental wares. His first tableware catalogue was published in 1774, the year in which the great service of nine hundred and fifty-two pieces was made for the Empress Catherine of Russia. The 1773 catalogue listed 285 cameos and intaglios, 82 bas-reliefs, medallions, and tablets, 23 busts and statues, and 609 portrait medals and medallions which included 254 Popes and the first 122 of the important medallions known as 'Heads of Illustrious Moderns'. In January 1771 Wedgwood had written to Bentley of 'new Experimts with several difft objects in view. Some of my present views are—first To make a white body, succeptible of being colour'd & which shall polish itself in burning

Bisket', and in September of the same year he was ready to contemplate producing portrait medallions of George III and Queen Charlotte, expressing himself 'fully perswaded a good deal may be done in that way with many of Their Majesty's subjects'.

The Introduction to the catalogue shows that remarkable progress had been made in two years, and gives a fair indication of the sizes and types of portrait available: 'We beg leave in this place to observe, that if gentlemen or ladies choose to have models of themselves, families, or friends, made in wax or engraven in stones of proper sizes for seals, rings, lockets, or bracelets, they may have as many durable copies of these models as they please, either in cameo or intaglio, for any of the above purposes, at a moderate expense; and this nation is at present happy in the possession of several artists of distinguished merit as engravers and modellers, who are capable of executing these fine works with great delicacy and precision. If the nobility and gentry of Great Britain should please to encourage this design, they will not only procure to themselves everlasting portraits, but have the pleasure of giving life and vigour to the arts of modelling and engraving. The art of making durable copies at a small expense will thus promote the art of making originals, and future ages may view the age of George III with the same veneration that we now gaze upon those of Alexander and Augustus. . . . A model of a portrait in wax, when it is of proper size for a ring, seal, or bracelet, will cost about three guineas; and if a portrait from three to six inches diameter, three, four, or five guineas. Any number of portraits from three to six inches diameter, not fewer than ten, we propose to make at ten shillings and sixpence each.' Of the heads of Illustrious Moderns listed in the catalogue, Wedgwood added: 'some . . . are made in black basaltes, and others in polished biscuit with cameo grounds; they are of various sizes and different prices, from one shilling apiece to a guinea, with or without frames of the same composition; but most are from two or three shillings apiece to seven and sixpence each'.

Wedgwood's catalogue was published in five English and three French editions between 1773 and 1788, by which time the number of cameos and intaglios had been increased to 1,091, bas-reliefs to 275, busts and statues to 133, and portrait medals and medallions to 857 of which 233 were of Illustrious Moderns. This list did not include the portraits of his family and friends, or those private commissions which were considered to lack public appeal. In the 1779 catalogue Wedgwood was able, for the first time, to advertise his new jasper, and he included a useful description of the various compositions then in production. These included 'A fine *Black Porcelaine* having nearly the same properties as the *Basaltes*; resisting the Attacks of Acids; being a Touchstone to Copper, silver and Gold; admitting of a good Polish, and capable of bearing to be made red hot in a furnace, frequently without damage'; 'A white waxen Biscuit Ware, or *Terra Cotta*; capable of bearing the same Heat of the *Basaltes*'; and 'A fine white artificial *Jasper*, of exquisite Beauty and Delicacy; proper for Cameos, Portraits, and Bas-reliefs'.

The invention of jasper, an original ceramic body which is technically a stoneware but displays many of the qualities of porcelain, was the triumphant outcome of more than ten thousand recorded experiments. Wedgwood began them at a time when the search for a formula for 'true' porcelain in the Chinese manner exercised the ingenuity of many of the British pottery manufacturers. Excluded by Cookworthy's patent until 1775 from the use of Cornish clay and china stone, Wedgwood looked elsewhere, including America and Australia, for other materials. There can be little doubt that his original purpose was the production of true porcelain, and it is significant that he generally described his jasper composition as 'porcellaneous'.

Wedgwood's pursuit of perfection, for nothing less would satisfy him, was long and arduous. The jasper body was fugitive and behaved with maddening inconsistency in the kiln. More than three years after his first mention of 'a white body, succeptible of being colour'd', Wedgwood wrote to Bentley:' I have for some time been reviewing my experiments, & I find such *Roots*, such *Seeds* as would open and branch out wonderfully if I could nail myself down to the cultivation of them for a year or two. And the Foxhunter does not enjoy more pleasure from the chace, than I do from the prosecution of my experiments when I am fairly enter'd into the field, & the farther I go, the wider this field extends before me. . . . The Black [basaltes] is sterling & will last for ever'. In July 1774 he admitted that the new white composition was far from certain: 'at one time the body is white & fine as it should be, the next we make perhaps . . . is Cinamon color. One time it is melted to a Glass, another time as dry as a Tob. Pipe'. Five weeks later he was able to report the despatch to London of a number of heads of Lady Charlotte Finch's daughters but he was not satisfied with them: 'They are all made, not only of the same materials, nominally, but out of the same Dish in which we grind the materials & all ground together, & all fired in the same sagar, & yet you will see what a difference there is amongst them. I cannot work miracles in altering the properties of these subtle, & complicated (though native) materials I had built my fabric upon.' Weary and depressed, he added: 'If I had more *time*, more *hands*, & more *heads* I could do something—but as it is I must be content to do as well as I can. A Man who is in the midst of experimts *shod not be at home* to anything, or anybody else but that cannot be my case. Farewell—I am almost crazy.' Four days later, on 3rd September, he had recovered his vitality and wrote of making 'an excellent white body, & with *absolute certainty*'.

On 1st January 1775, in answer to a letter of Bentley's which evidently indicated his approval of samples of the new white ceramic body, Wedgwood announced his ability to stain it blue 'of almost any shade . . . likewise a beautifull Sea Green, & several other colors', and his belief that he would be able to produce it 'in heads from Peter the Great to the smallest Gem for Rings, of the blue, & other color'd grounds, with the Figures & Heads in our fine white composition'. The Peter the Great portrait medallion had already been produced in basaltes, being listed in the 1773 catalogue as 'a fine medallion 17 in. × 14 in.'. His confidence was at length justified, for the records of ware fired in May 1779 include a medallion of this subject measuring 18 in. on a blue ground.

Wedgwood's difficulties with jasper were not over. Many of them sprang from his initial inability to differentiate between the sulphate and the carbonate of barium, but even after this problem of analysis had been solved, jasper remained 'the most delicately whimsical of any substance' and many of the variations of shade were unintentional.

The majority of Wedgwood's portraits were not original: they were adapted or re-modelled from casts of existing medals, reliefs cast in glass paste, carvings in ivory, wax portraits, or horn medallions. The rest were modelled in wax, either *ad vivum* or from engravings, drawings, portraits in oils, or sculpture, by artists employed or commissioned by Wedgwood. The largest source were the medallists, and many of the classical and French portraits were copied from medals by the Dassier family, Duvivier, Dupré, and Pesez. The method of producing Wedgwood copies of medals is described in a letter dated 1st and 2nd August 1777: '[we] can take a clay mould from a medal, that will last for ever, & continue its sharpness, but from a mould we must first make a medal, then burn it, & take a mould in clay from this burnt medal. This clay mould must likewise be burnt, & lastly the medals requir'd must be made out of

these clay moulds, so that the operations are multiplied, & the medal diminish'd very much by having our original in a mould'. This process applied to the production of the portrait medallions which are, without exception, noticeably smaller than the original reliefs from which they were copied.

The glass paste portraits produced by James Tassie also provided an important source for the Wedgwood medallions. In 1763 James Tassie, a young Scottish modeller, went to Dublin in search of employment. While there he met Dr. Henry Quin, a connoisseur and scientist, who had been working for some years on the invention of a composition to imitate semi-precious stones. Together they perfected the glass paste composition in which Tassie later cast cameos, intaglios, and portrait medallions. Tassie moved to London in 1766 and was awarded a bounty by the Society of Arts for 'Profiles in Pastes'. Two such portraits were exhibited by him at the Society of British Artists in 1768. The rivalry between Tassie and Wedgwood was admitted but remained friendly and they supplied one another with casts of portraits to be reproduced in jasper or glass paste. Those modelled by Tassie himself were signed, and often dated, on the truncation, and these details also appear on the Wedgwood copies.

Among the principal modellers whose work was reproduced by Wedgwood were William Hackwood, John Flaxman R.A., John Charles Lochée, Joachim Smith, John De Vaere, and Eley George Mountstephen. Of these only Hackwood was employed exclusively by Wedgwood. In a letter to Bentley dated 20th September 1769, Wedgwood describes him as 'an Ingenious boy. He has modelled at nights in his way for three years past, has never had the least instruction, which circumstances considered he does things amazingly, and will be a valuable acquisition'. Hackwood was hired for five years. He retired in 1832, completing an astonishing sixty-three years' service with the Wedgwood firm. Doubtfully permitted in 1771 to attempt the portrait of young 'Master Crew', he rapidly made himself so indispensable that by July 1776 Wedgwood was already wishing 'we had half a dozen more Hackwoods'. The vigour of his modelling is well demonstrated in the profile portraits of Bourne and Willet (10 & 100) and the fine bust of Lord Anglesey (3). Hackwood's original work shows the use of deep relief and a sharply truncated rather square bust, but many of his portraits are less easily recognizable as they were re-modelled from medals or medallions by other artists.

John Flaxman the younger was also responsible for many of the medallions re-modelled from medals and ivory carvings. His distinction as a sculptor and modeller fostered the false assumption that all the finest portraits were from his hand, and it is only during the past twenty years that more thorough research has contradicted this. The rediscovery of a small collection of his original wax models has also added valuable fresh evidence of his methods of working (see 9a, 22a, 76a). Flaxman had won the Gold Palette of the Society of Arts at the age of fifteen for a statue of Garrick, and appears to have begun to execute commissions for Wedgwood some four years later. In January 1775 Wedgwood wrote to Bentley, 'I am glad . . . Flaxman is so valuable an Artist. It is but a few years since he was a most supreme Coxcomb.' A year later Wedgwood was exhorting his partner to 'give Flaxman a head or two to Model as it may excite our Modelers emulation'. It was Flaxman who advised Wedgwood about the plaster decoration for the rooms of Etruria Hall, and in 1787 Wedgwood subsidized his extended stay in Rome, where he supervised the work of the modellers employed there to copy antique friezes. Two years after Wedgwood's death Flaxman was elected an Associate of the Royal Academy, and he became a full member in 1800. His monumental sculpture was said to have made for him 'a higher reputation than any artist of our country excepting Sir Christopher Wren and

Sir Joshua Reynolds', and his employment by Wedgwood is a tribute to Bentley's acumen.

Joachim Smith was probably the first modeller to be commissioned to model portraits specifically for reproduction in basaltes and polished biscuit, and his early medallions were later reproduced also in jasper. He exhibited wax portraits at the Free Society of Arts between 1760 and 1783, and at the Royal Academy from 1781 to 1803. Smith does not appear to have been employed by Wedgwood on any regular basis but it is clear that he was providing wax portraits or casts from them to be copied at Etruria by 1773 and it is likely that Wedgwood obtained work from him at least a year earlier. His portraits are distinguished by fine, uncluttered modelling and the frequent use of a long, straight-backed, profile bust which is nearly waist-length.

John Charles Lochée was both sculptor and modeller, and exhibited at the Royal Academy for the first time in 1776. It is clear from Wedgwood's correspondence that Lochée supplied moulds of his work to Wedgwood as early as 1774, and some years later Josiah II had cause to complain that they were 'in general very bad, sometimes they appear to have had waxes taken out of them—& I believe they are very full of pin holes'. Between 1786 and 1790 Lochée modelled portraits of many of the Royal Family, several of which were reproduced by Wedgwood. His modelling shows a certain rococo opulence, with distinctive heavy folds concealing the truncations, and much elegant detailing of fur, ribbons, and orders.

It was on Flaxman's recommendation that John De Vaere was commissioned by Wedgwood in 1787, and in the following year he accompanied Flaxman to Rome to copy bas-reliefs. After his return to England in 1790 he was employed by Wedgwood at Etruria. Apart from his portraits of Admirals Nelson, Howe, Duncan, and St. Vincent, few of his medallions have been identified. Little is known of the Irishman, Eley George Mountstephen, who exhibited wax portraits at the Royal Academy between 1782 and 1791. As he did not move to England from Dublin until 1781 it seems likely that he owed his introduction to Wedgwood either to another modeller or, perhaps, to Sir Joshua Reynolds. His portrait of Sir Eyre Coote gives a fair indication of his ability and must be considered one of the finest of all jasper medallions. Mountstephen returned to Ireland in 1791 and there is no evidence of any of his later portraits being reproduced by Wedgwood after that date.

Casts taken from portraits carved in ivory provided a small but useful source for Wedgwood medallions. Those carved by David Le Marchand (1674–1726) and Silvanus Bevan (1691–1765) are distinctive in style, and recent researches among the moulds at the Wedgwood factory have uncovered the existence of a number of interesting portraits which were unrecorded either in jasper or the original ivory. Bevan's portrait of Dr. Richard Mead (69a) is of special interest as it is possible to compare the original ivory with the intermediate copy made in wax and the final medallion in jasper.

Although some of the Wedgwood portrait medallions are the recorded work of identified artists, and others may be attributed with some confidence on grounds of style, the greater number cannot be described with any certainty as the work of a particular modeller. Wedgwood would not allow his modellers to sign their work (though a few medallions are, nevertheless, signed on the truncation), and the individual style of a modeller was often disguised or submerged altogether when he worked from a medal or relief portrait by another hand. Few of the modellers' original waxes survive. The majority of those described as original are later casts taken from the jasper medallions, and these frequently bear spurious and misleading signatures.

The identification of the medallions is unexpectedly complicated. The early printed catalogues, and the existence at the factory of most of the moulds, provide a useful nucleus of information, but many of the moulds are unmarked or have been incorrectly identified in the past, and it is clear that certain of the portraits were wrongly named when they were first issued. It is fitting that the bicentenary of Wedgwood's first catalogue should be marked by an exhibition of his portrait medallions and also by the publication of the first illustrated catalogue raisonné ever attempted.*

Wedgwood portrait medallions were collected during Wedgwood's lifetime, and they are now among the most highly prized of all his productions. The importance of Bentley's contribution to the partnership, which lasted from 1769 until his death in 1780, and the existence of much fine work which is undeniably of that period, have tended to over-emphasize the importance of the Wedgwood & Bentley mark on jasper. It should not be forgotten that Wedgwood's experiments to perfect the jasper body continued after the death of his partner and that he remained in charge of the factory until 1790, five years before his death. His most important work in jasper, including all the vases and many of the finest medallions, was produced after 1780. The impressed mark on the reverse of a Wedgwood medallion, like the signature on a painting, should be considered as no more than subsidiary evidence of authenticity and period, confirming the evidence already recognizable in the quality of the jasper and the sharpening of detail produced by undercutting. The jasper body of the best period is even and smooth, with a feeling to the touch somewhat similar to freshly cut cheese. Later jasper tends to be granular like refined lump sugar. Undercutting was the sharpening of features carried out by a modeller when the portrait was in the clay state (known as 'cheese-hard') before firing. It is most noticeable in those parts where the cutting is on a plane parallel with that of the medallion, as details on a vertical plane only can be reproduced from a mould.

Wedgwood's jasper was produced in six basic colours—blue, dark blue, green, lilac (pink), black, yellow—and the very rare experimental grey and brown, in addition to the basaltes and white biscuit for medallions: variations on these colours were experimental or the accidental results of differing mixtures and firing conditions. They were sometimes provided with frames of the same material, either moulded with the background or made separately, often in a contrasting colour. Grounds to the portraits were either 'solid' (jasper of the same colour throughout) or 'dip' (jasper of one colour dipped or washed in another), and the edges, either cut square or slightly bevelled, were occasionally polished on the lapidary wheel.

'We can now', Wedgwood wrote to Bentley on 12th December 1774, 'certainly make the finest things in the world for Portraits.' The claim was premature and over-ambitious, but the final achievement was remarkable. Without formal scientific training Wedgwood created an original and beautiful ceramic composition. Without any education in history or the arts he understood how to exploit the invention so that his work would continue to excite the admiration of connoisseurs long after the fashion which had inspired it had faded. Wedgwood did not suffer from false modesty. He appreciated the quality of jasper and described his portraits as 'everlasting', claiming that 'no *Cameos*, *Medallions*, or *Bas-reliefs*, so highly finished [had] ever been made in such durable and exquisite Materials'. He would have found it gratifying that, two centuries later, his portrait medallions should be the subject of an exhibition at the National Portrait Gallery, but he would not have been surprised.

* *Wedgwood: The Portrait Medallions*. Robin Reilly & George Savage (Barrie & Jenkins).

1

2

1. ALEXANDER I, 1777–1825 and CONSTANTINE, 1779–1831

Alexander I, Emperor of Russia, and his brother, Grand Duke Constantine, sons of Paul I and Maria of Württemberg. Alexander succeeded to the throne, 1801. He allied himself with Napoleon in 1808 but was soon disillusioned and led resistance to the French invasion in 1812. After his death, Constantine was proclaimed emperor but renounced his claims in favour of his younger brother, Nicholas.
Green dip. 3¼ in. WEDGWOOD
Modelled by their mother, Maria Feodorowna, 1791
British Museum

2. AMALIA, Princess of Orange, fl. 1625–60

Daughter of Count Solms, and one of the ladies in attendance upon Elizabeth of Bohemia at the Hague. Of the Solms parents Elizabeth had written 'you remember him by his red face and her . . . by her fatness'. Amalia married Prince Frederick Henry of Orange-Nassau, Stadholder of the Dutch Republic (1625–47).
Solid pale blue jasper. 5 in. WEDGWOOD MADE IN ENGLAND.
(Reproduction made in 1972)
From the horn medallion by John Osborn (**2a**). First produced about 1790
Wedgwood Museum, Barlaston

2a. Pressed horn medallion by John Osborn, inscribed and dated 1626. Pair to the portrait by Osborn of Prince Frederick Henry. The Wedgwood medallion was for many years incorrectly identified as Elizabeth of Bohemia. 5½ in.
British Museum

2a

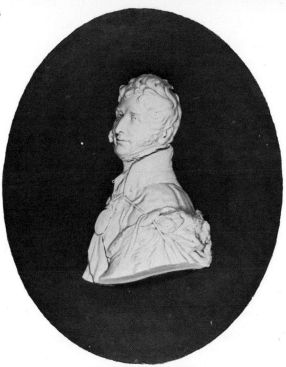

3. Sir Henry William Paget, 1st Marquess of ANGLESEY, 1768–1854
Field-marshal. Member of Parliament, 1790–1810. Served
with distinction in the Peninsular War and commanded
Wellington's cavalry at Waterloo, where he lost a leg. Lord-
Lieutenant of Ireland, 1828–33, and Master of the Ordnance, 1846.
Blue jasper dip. 9 in. Unmarked. Signed 'W. Hackwood' on the
truncation. Probably modelled from the engraving by Thompson,
1821, after the painting by Beechey
City Museum and Art Gallery, Stoke-on-Trent

4. William Eden, 1st Baron AUCKLAND, 1744–1814
Statesman and diplomat. Ambassador extraordinary at the Hague
during the French Revolution; Postmaster-General, 1798–1804;
President of the Board of Trade, 1806–7. Created Baron
Auckland in the Irish peerage, 1789, and Baron Auckland
of West Auckland, Durham, 1793.
Pale blue dipped darker blue. $4\frac{7}{16}$ in. WEDGWOOD
Modelled by Eley George Mountstephen and first produced in
1790. On the 14th November 1790 Wedgwood wrote to Lord
Auckland: 'A few portraits will be sent with the other articles, and
I shall be happy if they meet with Lady Aucklands & your
approbation.' It seems likely that he referred to the first satisfactory
examples of these medallions to be completed
British Museum

4a. Relief portrait in pink wax modelled by Eley George
Mountstephen about 1790. Mounted on the original painted glass.
The wax relief measures $3\frac{7}{8}$ in. (extreme height from head to
lowest part of truncation). The equivalent measurement of the
jasper medallion is $3\frac{3}{8}$ in., showing the allowance required for
shrinkage in firing
Reilly Collection

5. Eleanor, Lady AUCKLAND, 1758–1818
Youngest daughter of Sir Gilbert Elliot and sister of Gilbert, first
Earl of Minto; wife of William Eden, first Baron Auckland.
Dark blue dip. $4\frac{7}{16}$ in. WEDGWOOD
Modelled by Eley George Mountstephen and first produced in 1790
British Museum

6. Sir Joseph BANKS, 1743–1820
Naturalist. Educated at Harrow, Eton, and Christchurch, Oxford.
Accompanied Captain Cook on his voyage of 1768 and introduced
sugar-cane and bread-fruit to the West Indian islands. Fellow of
the Royal Society, 1766; created baronet, 1781; Privy Councillor,
1797. Wedgwood produced three portrait medallions of Sir
Joseph Banks, including one measuring nearly 11 in.
Lilac dip. $3\frac{1}{2}$ in. WEDGWOOD
Modelled by John Flaxman Jnr., about 1775
Wedgwood Museum, Barlaston

7. Lady BANKS, 1758–1828
Daughter of William Western Hugessen of Provender, Kent.
Married Sir Joseph Banks, 1779.
Lilac dip. $3\frac{1}{2}$ in. WEDGWOOD
First produced about 1782
Wedgwood Museum, Barlaston

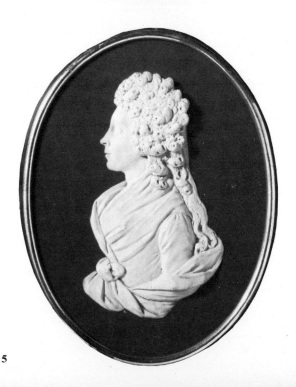

4
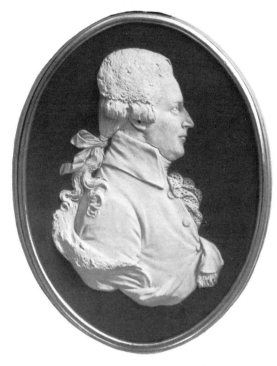

4a
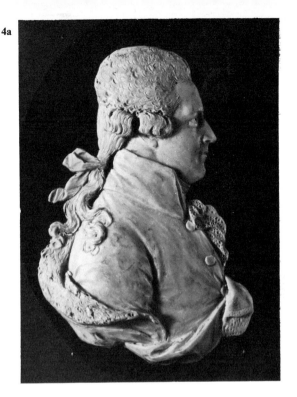

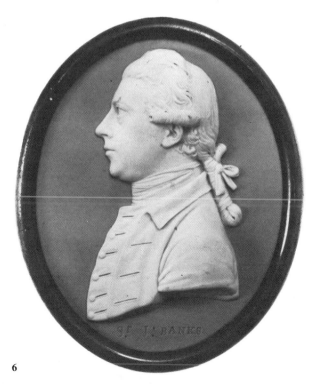
6

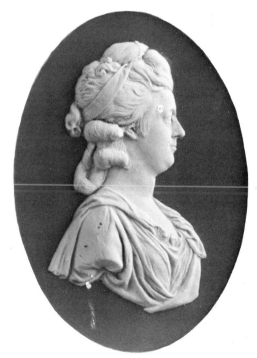
7

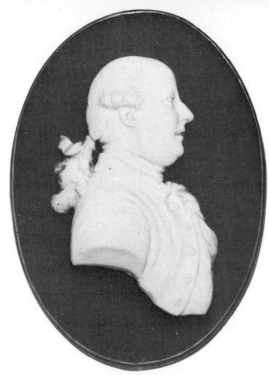

8. Thomas BENTLEY, 1731–80
Liverpool merchant. Wedgwood's partner in the manufacture of
ornamental ware, 1769–80, and his intimate friend. Bentley was
in charge of Wedgwood's London showrooms and decorating
studio, and his influence in matters of taste was paramount.
Black dip. 3½ in. WEDGWOOD
Modelled by Joachim Smith about 1773 as a pair to his portrait of
Josiah Wedgwood
Manchester City Art Galleries

9. Hermann BOERHAAVE, 1668–1738
Dutch physician. Studied medicine, Oriental languages,
philosophy, and theology at Leiden. Professor of Medicine and
Botany there, 1709, and of Chemistry, 1718. Author of
encyclopedic medical books which were translated into several
European languages.
Solid blue jasper. 4½ in. WEDGWOOD MADE IN ENGLAND
(Reproduction 1951)
Modelled by John Flaxman Jnr., 1782, from a medal by Pesez
Wedgwood Museum, Barlaston

9a. Wax portrait by John Flaxman Jnr., modelled in 1782.
(Maximum relief measurement 3⅛ in.)
Reilly Collection

10. Edward BOURNE, *c*.1710–80
Bricklayer at Etruria and probably the character mentioned by
Simeon Shaw (*History of the Staffordshire Potteries*, 1829).
Blue dip. 4¾ in. with black jasper frame. Unmarked
Modelled by William Hackwood, 1779. Of this portrait Wedgwood
wrote: 'Old Bourne's is the man himself with every wrinkle, crink
and cranny in the whole visage'
Wedgwood Museum, Barlaston

11. Dr. William BUCHAN, 1729–1805
Physician and medical author. Studied medicine at Edinburgh
and practised in Yorkshire and Edinburgh before settling in
London in 1778. He published a number of medical tracts, and
Domestic Medicine, 1769, one of the first popular medical books
to induce hypochondria in the home.
Blue dip. 4⅛ in. WEDGWOOD
Modelled by John Flaxman Jnr. in 1783
British Museum

**12. George Nugent-Temple Grenville, 1st Marquess of
BUCKINGHAM, 1753–1813**
Statesman. Member of Parliament,1774–79; succeeded as second
Earl Temple, 1779. Privy Councillor and Lord-Lieutenant of
Ireland, 1782–83 and 1787–89. Procured, on the King's
instructions, the defeat of Fox's India Bill in the House of Lords,
1783. Created Marquess of Buckingham, 1784.
Solid pale blue jasper. 3¾ in. WEDGWOOD
Modelled by John Charles Lochée (*b*.1751) from a plaster mask
and a portrait supplied by Vincent Waldré in 1788
Wedgwood Museum, Barlaston

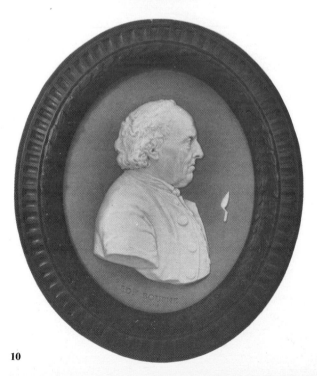

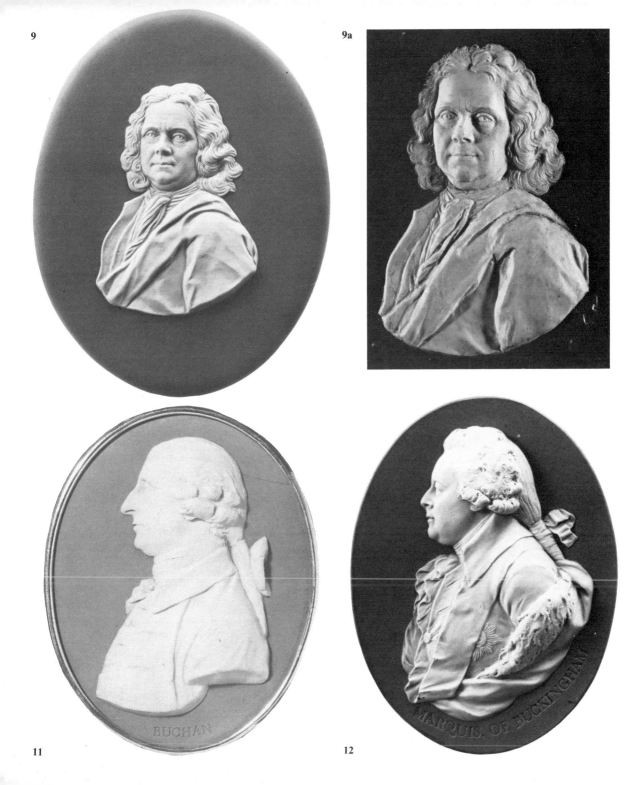

9

9a

11

12 MARQUIS OF BUCKINGHAM

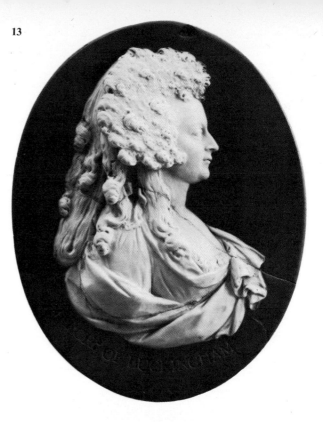

13. Mary Elizabeth Nugent, Marchioness of BUCKINGHAM, 1759–1812
Only daughter and heiress of Robert Nugent, Viscount Clare and Earl Nugent, from whose *penchant* for marrying rich widows Horace Walpole invented the verb 'to Nugentize'. Married, 1775, George Grenville, later Marquess of Buckingham.
Solid pale blue jasper. 3¾ in. WEDGWOOD
Modelled by John Charles Lochée in 1788
Wedgwood Museum, Barlaston

14. Thomas BYERLEY, 1742–1810
Nephew of Josiah Wedgwood and partner in the firm from 1790 to 1810. From unpromising beginnings, Byerley became a responsible and capable salesman and administrator. After Wedgwood's death in 1795, Byerley assumed responsibility for control of the firm until the return of Josiah II to the factory.
Blue dip. 4 in. Unmarked
Modelled by William Theed, 1810
Wedgwood Museum, Barlaston

15. Sir Charles Pratt, 1st Earl CAMDEN, 1714–94
Lord Chancellor. Educated at Eton and King's College, Cambridge. Attorney-General in Pitt's administration, 1757; Member of Parliament; Chief Justice Court of Common Pleas, 1761. Achieved great public popularity by impartial judgments, especially in favour of John Wilkes. Lord Chancellor, 1766; Lord President of the Council, 1782, and 1784–94. Created Earl Camden, 1786.
Green dip. 3¾ in. WEDGWOOD
Wedgwood Museum, Barlaston

16. CATHERINE II ('The Great'), 1729–96
Empress of Russia. Married Peter, heir to Russian throne, 1745; usurped throne after murder of her husband (Peter III), 1762. Expanded her territories by conquest, enriched her country by the purchase of great art collections, and exhausted her many lovers by her demands. Commissioned from Wedgwood the great creamware service of 952 pieces for the palace of La Grenouillère at St. Petersburg, 1773.
Solid blue jasper. 3 in. WEDGWOOD
Modelled from a medal by T. Ivanov, 1774, and first produced about 1779
Wedgwood Museum, Barlaston

17. CHARLOTTE Augusta Matilda, 1766–1828
Princess Royal. Eldest daughter of George III; married, as his second wife, Frederick William Charles, Prince of Württemberg, 1797. Queen of Württemberg, 1806.
Solid blue jasper. 3¾ in. WEDGWOOD
Attributed to John Charles Lochée, about 1787
Wedgwood Museum, Barlaston

18. CHARLOTTE Sophia, 1744–1818
Queen Consort of George III. Daughter of Duke of Mecklenburg-Strelitz; married, 1761. Ordered a creamware tea-service from Wedgwood, 1765; creamware re-named 'Queensware' by her command, 1767. Seven Wedgwood portrait medallions of Queen Charlotte have been identified.
Blue dip. 3½ in. WEDGWOOD
Re-modelled by William Hackwood, 1776, from his earlier portrait based on a wax portrait by Isaac Gosset (1735 ?–1812)
Wedgwood Museum, Barlaston

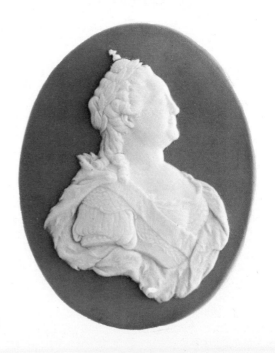

16

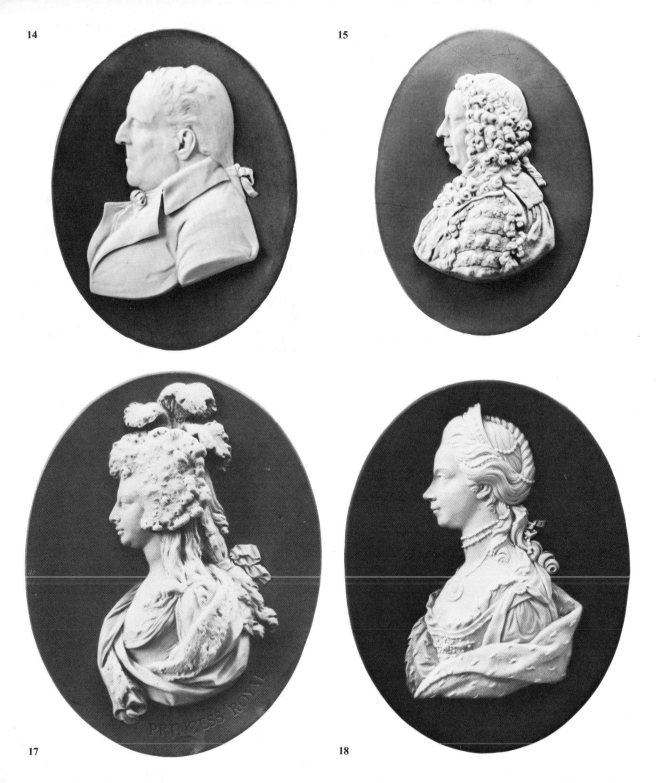

14

15

17

18

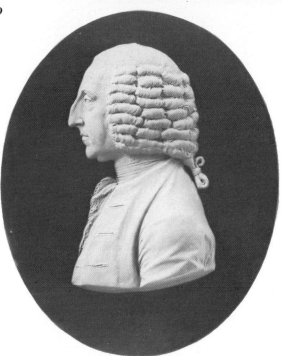

19. William Pitt, 1st Earl of CHATHAM, 1708–78
Statesman. Entered parliament, 1735; Paymaster-General and
Privy Councillor, 1746; principal Secretary of State, 1756; premier,
1757–61. His vigorous prosecution of the war largely
responsible for defeat of French in India, Africa, and Canada.
Opposed taxation of American colonies. Accepted earldom in 1766.
Opposed American war but did not support independence.
Pale blue jasper dipped blue-black. 4 in. WEDGWOOD & BENTLEY
Modelled by John Flaxman Jnr., 1778
Wedgwood Museum, Barlaston

20. Louise de COLIGNY, 1555–1620
Princess of Orange. Daughter of Gaspard de Coligny, Admiral of
France and leader of the Huguenots. Married, as her second
husband, William I ('William the Silent') of Orange in 1583.
Cream-coloured earthenware. Ground enamelled chocolate-
brown. $4\frac{5}{16}$ in. WEDGWOOD
Attributed to John Flaxman Jnr. and modelled from an engraving
by Houbraken after Schouman
Royal Scottish Museum, Edinburgh

21. James COOK, 1728–79
Navigator and explorer. Distinguished himself in war with France,
1755, and as master of the *Mercury*, 1759, at siege of Quebec.
Conducted official surveys of American waters and wrote accounts
of voyages. In command of *Endeavour*, 1768, circumnavigated
New Zealand and charted part of coast of Australia. Captain,
Royal Navy, 1775. Made voyages to South Seas, 1772 and 1776;
killed by natives of Sandwich Islands.
Solid blue jasper. $3\frac{1}{4}$ in. WEDGWOOD
Attributed to John Flaxman Jnr. after the portrait by William
Hodges
Wedgwood Museum, Barlaston

22. COOK
Pale blue dip. 4 in. WEDGWOOD. (Maximum relief measurement
$3\frac{1}{8}$ in.)
Modelled by John Flaxman Jnr., 1784
Nottingham Museum & Art Gallery

22a. Wax portrait by John Flaxman Jnr., 1784. Maximum relief
measurement $3\frac{11}{16}$ in. Probably adapted from the Royal Society
Medal by Lewis Pingo, 1779
Reilly Collection

23. Sir Eyre COOTE, 1726–83
General. Served in Scotland against Prince Charles Edward
Stuart, 'The Young Pretender', in 1745. Sailed for India, 1754,
and was instrumental in persuading Clive to attack Suraj ud
Dowlah at Plassey, 1757. Distinguished himself at Wandewash,
1759–60, and Pondicherry, 1761. Returned to England. Became
M.P. for Leicester, 1768. Commander-in-Chief Madras, 1769, but
resigned shortly afterwards. Commander-in-Chief India, 1777.
Defeated Hyder Ali in a series of battles during the latter half of
1781. Died in Madras.
Solid blue jasper. $4\frac{1}{8}$ in. WEDGWOOD
Modelled by Eley George Mountstephen in 1788. Frequently
catalogued in the past as 'Ferdinand IV, King of the Two Sicilies'
and erroneously attributed to Flaxman. Evidently modelled from
the bust by Nollekens (**23a**) or one of the sculptor's sketches for it.
British Museum

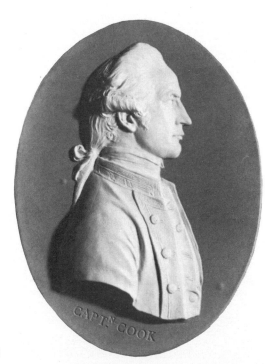

20

21

22a

23

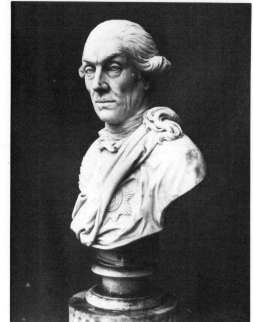

23a. Marble bust by Nollekens. Height 28½ in. Signed and dated 1779. Possibly the 'bust of a General' exhibited in the Royal Academy in 1779 and certainly that referred to by J. T. Smith (*Nollekens and His Times* 1829 II.68) in his list of the sculptor's work.
Private Collection

23b. Bronze medallion 4⅜ in. with gilded laurel border. Previously catalogued as 'Lord Amherst' and evidently from the same source as the Wedgwood medallion.
National Museum of Wales, Cardiff

24. Peter Biren, Duke of COURLAND, 1742–1800
Eldest son of Ernst Johann, Duke of Courland. Succeeded his father, 1769, but deposed by Catherine II, 1795, and fled to Prussia. Returned to Russia and sold his lands (the Baltic province of Kurland) to the Empress.
Solid blue jasper. 3¼ in. WEDGWOOD
Wedgwood Museum, Barlaston

25. George Nassau Clavering-Cowper, 3rd Earl COWPER, 1738–89
Succeeded his father as Earl Cowper, 1764. Lived for many years in Florence; titular Prince of Nassau, 1777; F.R.S., 1777; Knight of St. Hubert, 1785. Acquaintance of Horace Walpole.
Solid blue jasper. 4½ in. WEDGWOOD
First produced between 1780 and 1787
Wedgwood Museum, Barlaston

26. Erasmus DARWIN, 1731–1802
Physician and botanist. Life-long friend of Josiah Wedgwood. His son, Robert Waring Darwin, married Wedgwood's daughter, Susannah; and their son, Charles Darwin, married his cousin, Emma Wedgwood. Erasmus created an 8-acre botanical garden near Lichfield, and published several volumes of poor verse in addition to works expounding a theory of evolution. Wedgwood called him 'my favourite Aesculapius'.
Blue dip. 5 in. WEDGWOOD
Attributed to William Hackwood and modelled, about 1779, after the portrait by Joseph Wright of Derby (**26a**)
Wedgwood Museum, Barlaston

26a. Portrait by Joseph Wright of Derby, 1770. Oil on canvas. 29¼ × 24¼ in. Wedgwood commissioned a number of paintings from Joseph Wright, including 'The Corinthian Maid' now in the Mellon Collection.
National Portrait Gallery, London

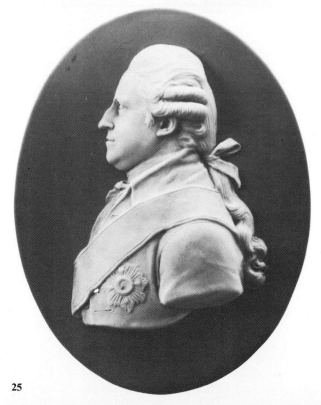

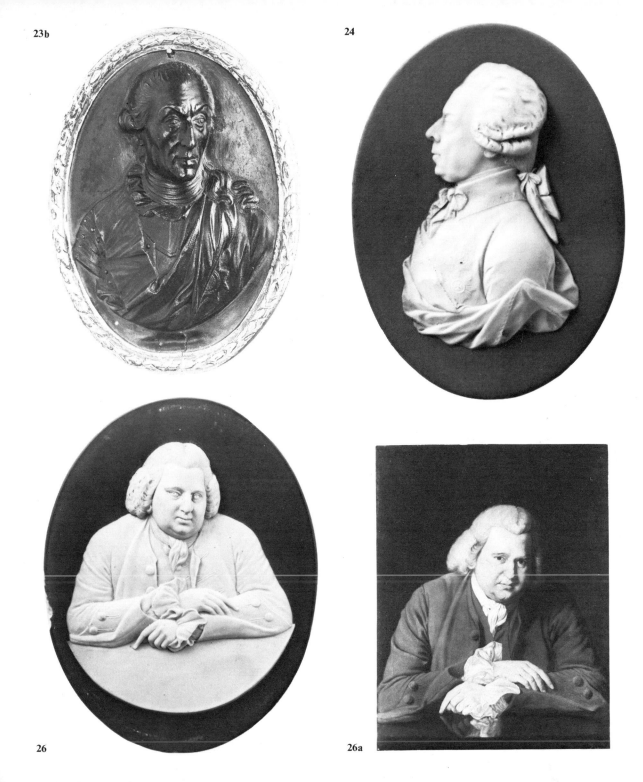

23b

24

26

26a

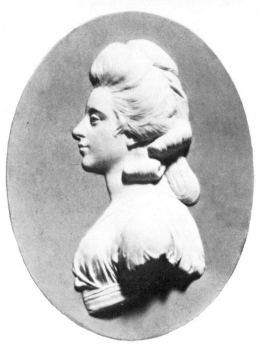

27. Georgiana Cavendish, Duchess of DEVONSHIRE, 1757–1806
Eldest daughter of 1st Earl Spencer; married fifth Duke of
Devonshire, 1774. One of the great beauties of the period, she
possessed unusual intellectual ability and was the friend of
Johnson, Sheridan, and Charles James Fox, for whom she
campaigned in the Westminster election of 1784.
Pale blue dip. $4\frac{1}{2}$ in. WEDGWOOD
Attributed to John Flaxman Jnr. and first produced in 1782
Nottingham Museum & Art Gallery

28. Honora Sneyd EDGEWORTH, d.1780
Daughter of Ralph Sneyd of Lichfield; married, 1773, as second
wife, Richard Lovell Edgeworth, the author and friend of Josiah
Wedgwood. Wedgwood described her as 'a very polite, sensible,
and agreeable lady . . . with a considerable share of beauty'.
Black dip. $2\frac{11}{16}$ in. Wedgwood. Inscribed verso 'Ground & head
2 of Last 1559/1 of 3614/Black wash'. Attributed to John Flaxman
Jnr. and modelled, at Edgeworth's request, in 1780, from a
silhouette by Mrs. Harrington and a miniature by Smart
Victoria & Albert Museum

29. George EDWARDS, 1694–1773
Naturalist. On the recommendation of Sir Hans Sloane, elected
librarian of Royal College of Physicians, 1733. Fellow of the
Royal Society. Author of a number of works in natural history,
the most important being his *History of Birds*, published 1743–64.
Solid blue jasper, obverse dipped darker blue. $3\frac{1}{4}$ in. WEDGWOOD
& BENTLEY. Trial piece. Scratch-marked formula '3 of No. 3 and 1
of New Mixd M'.
Modelled by Isaac Gosset
Wedgwood Museum, Barlaston

30. John Philip ELERS, fl.1686–1730
Potter. Born in Saxony; came to England with his brother, David.
before 1686, settling in Hammersmith. Imitated brown stoneware
of Cologne; sued by John Dwight for infringement of patent,
1693; moved to Staffordshire about 1693 and continued to produce
red stoneware teapots in imitation of Yi-hsing wares.
Blue dip in lustre earthenware frame. $3\frac{3}{8}$ in. Unmarked
Modelled by William Hackwood, 1777, at the request of Elers's
son. Paul
Private Collection

30a. Wax portrait modelled by William Hackwood about 1777,
probably from a portrait supplied by Elers's son. On the 19th July
1777, Wedgwood relayed to the factory a request from Paul
Elers for 'about half a dozn more of the Portraits, for his friends
are pretty numerous'. (Maximum relief measurement $3\frac{1}{4}$ in.)
Reilly Collection

31. John FLAXMAN Jnr., 1755–1826
Sculptor and modeller. Son of modeller, John Flaxman the elder.
Awarded premiums by Society of Arts, 1766 and 1769; Royal
Academy silver medallist, 1771; produced models and designs for
Wedgwood, 1775–94. Royal Academician, 1800; Professor of
Sculpture, Royal Academy, 1810.
Green dip. 6 in. *diameter*. WEDGWOOD
A self-portrait probably modelled between 1787 and 1794
Wedgwood Museum, Barlaston

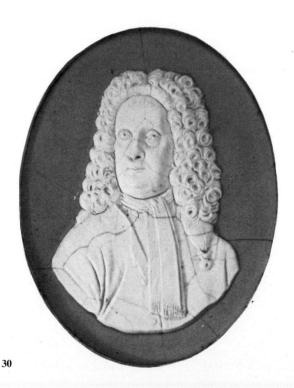

30

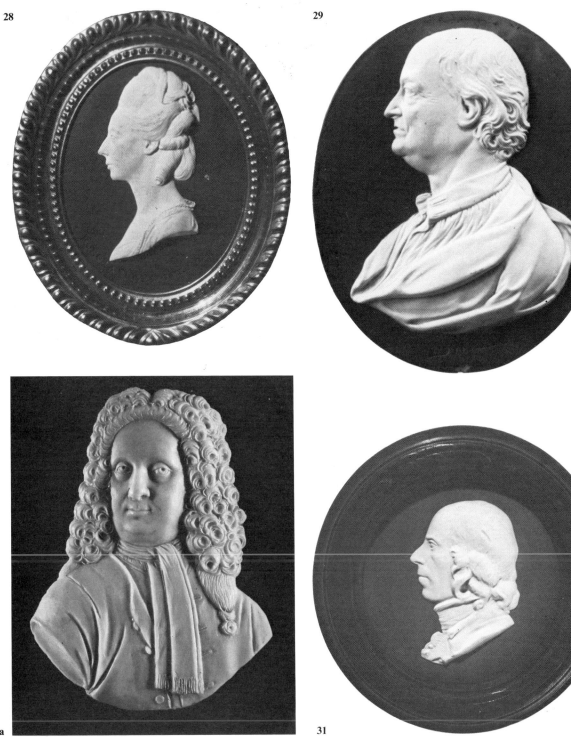

28

29

30a

31

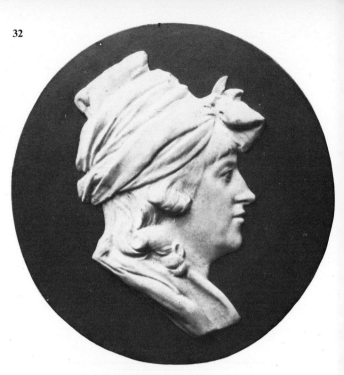

32. Mrs. FLAXMAN, d.1820
Born Ann Denman, daughter of a Whitechapel gunstock-maker.
Married John Flaxman Jnr., 1782; accompanied him to Rome,
1787. An accomplished artist, she was awarded the silver medal of
the Society of Arts. Her brother, Thomas, worked in Flaxman's
studio.
Green dip. 6 in. *diameter*. WEDGWOOD
Modelled by John Flaxman Jnr. between 1787 and 1794
Wedgwood Museum, Barlaston

33. Johann Reinhold FORSTER, 1729–98
Prussian naturalist and philosopher. Studied at university of
Halle; teacher of natural history at Warrington. Accompanied
Captain Cook on voyage to South Seas, 1772. Professor of Natural
History at Halle University, 1780–98.
Blue dip. $3\frac{7}{16}$ in. WEDGWOOD
Modelled by Joachim Smith, 1776. A second portrait, also by
Joachim Smith, was produced by Wedgwood
Nottingham Museum & Art Gallery

34. Charles James FOX, 1749–1806
Statesman. Third son of Lord Holland, who procured for him a
seat in parliament in 1768 when he was nineteen. A Lord of the
Admiralty, 1770–72, and of the Treasury, 1772–74; opposed
coercion of American colonies; urged abolition of slavery; Foreign
Secretary after death of Pitt, 1806, but died nine months later.
Dark blue dip. $3\frac{9}{16}$ in. WEDGWOOD
Attributed to John Flaxman Jnr. and probably modelled from the
portrait by Sir Joshua Reynolds, *c*.1790
Wedgwood Museum, Barlaston

35. Benjamin FRANKLIN, 1706–90
American statesman, scientist, and philosopher. Member of the
Pennsylvania legislature from 1751 to 1764. Assisted in drafting
the Declaration of Independence and the American Constitution.
Founded the University of Pennsylvania. Fellow of the Royal
Society.
Pale blue dip, obverse dipped darker blue. $10\frac{3}{4}$ in. WEDGWOOD &
BENTLEY
One of the series of large portraits, first produced in 1779, which
included Boyle, Hamilton, Newton, Priestley, and Solander. No
less than eight different portraits of Franklin were produced by
Wedgwood between 1775 and 1790
British Museum

36. William FRANKLIN, 1731–1813
Son of Benjamin Franklin. Appointed by his father Comptroller-
General of the Post Office (1754–56) and accompanied him to
England in 1757. Appointed governor of New Jersey, 1765, but
upheld royal authority in the colonies and was estranged from
his father. His arrest was ordered by the Provincial Congress of
New Jersey in 1776, and six years later he settled in England.
Blue dip. 4 in. WEDGWOOD
British Museum

37. William Temple FRANKLIN, 1760–1823
Natural son of William ('Governor') Franklin. Acted as
secretary to his grandfather, Benjamin Franklin, in Paris, and
later edited an edition of his works.
Blue dip. $4\frac{5}{16}$ in. WEDGWOOD
Attributed to John Flaxman Jnr.
Nottingham Museum & Art Gallery

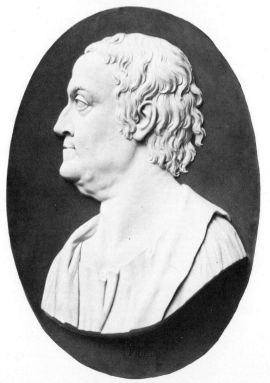

33 34

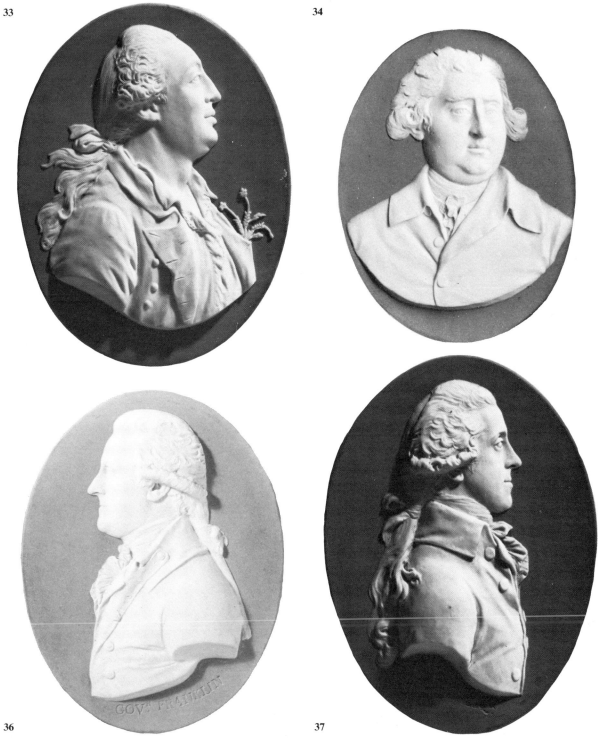

36 37

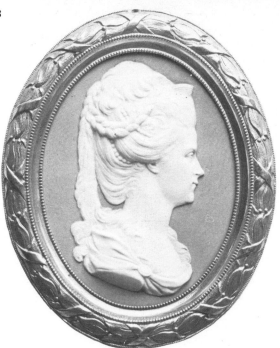

38. FREDERICA Sophia Wilhelmina, 1751–1820
Princess of Orange. Niece of Frederick the Great of Prussia.
Married William V, Stadholder of Holland and dominated her
weak husband.
Lilac dip. $3\frac{7}{16}$ in. WEDGWOOD
First produced by Wedgwood in 1782
British Museum

39. FREDERICK I, 1754–1816
King of Württemberg. As Prince Frederick William Charles,
married, 1797, Charlotte Augusta Matilda, British Princess
Royal. Acquired title of King from alliance with Napoleon, 1805,
but joined Allies after defeat of French at Leipzig, 1813.
Black dip. $5\frac{1}{4}$ in. WEDGWOOD
Probably modelled in 1797 after the biscuit porcelain medallion
produced by the Ludwigsburg factory, *c.*1775. Often described
as Duke of Bridgewater
Wedgwood Museum, Barlaston

40. FREDERICK II ('The Great'), 1712–86
King of Prussia. Son of Frederick William I, and grandson of
George, Elector of Hannover and future British sovereign. One
of the greatest military commanders in history, displaying genius
in Silesian Wars, especially the Seven Years War (1756–63).
Notable patron of literature and the arts; laid foundations of
Prussian economic strength; sympathized with American
Revolution.
Blue dip on buff-coloured jasper. $2\frac{3}{4}$ in. WEDGWOOD & BENTLEY
Trial piece scratch-marked with formula 'lm/lc/1No.1559/1
Dish flint in'
Wedgwood Museum, Barlaston

41. FREDERICK Augustus, Prince, 1763–1827
Duke of York. Second son of George III and Queen Charlotte;
married Charlotte Ulrika Catherine, daughter of Frederick
William II of Prussia. Served with courage and some distinction
in the army and was appointed commander-in-chief, but resigned
after inquiry involving his mistress, Mary Anne Clarke, 1809;
re-appointed, 1811.
Pale blue jasper dipped darker blue. $3\frac{11}{16}$ in. WEDGWOOD
Modelled by John Charles Lochée, 1787
Nottingham Museum & Art Gallery

42. FREDERICK HENRY, Prince of Orange, 1584–1647
Stadholder of the Dutch Republic, 1625–47. Son of William the
Silent; married Amalia of Solms. Received military training from
his brother, Prince Maurits; captured many important cities from
the Spanish between 1629 and 1645; concluded favourable treaty,
1647.
Solid pale blue jasper. 5 in. WEDGWOOD MADE IN ENGLAND.
(Reproduction made in 1972)
Copied from the horn medallion by John Osborn (**42a**). First
produced about 1790
Wedgwood Museum, Barlaston

42a. Pressed horn medallion by John Osborn, inscribed and
dated 1626. Pair to the portrait by Osborn of Princess Amalia.
The Wedgwood medallion was for many years identified as
Frederick V of Bohemia. $5\frac{1}{2}$ in.
British Museum

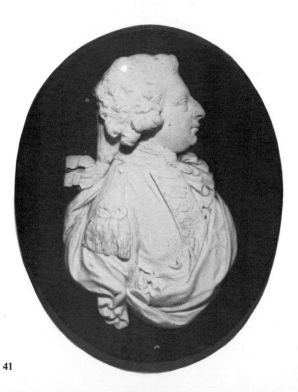

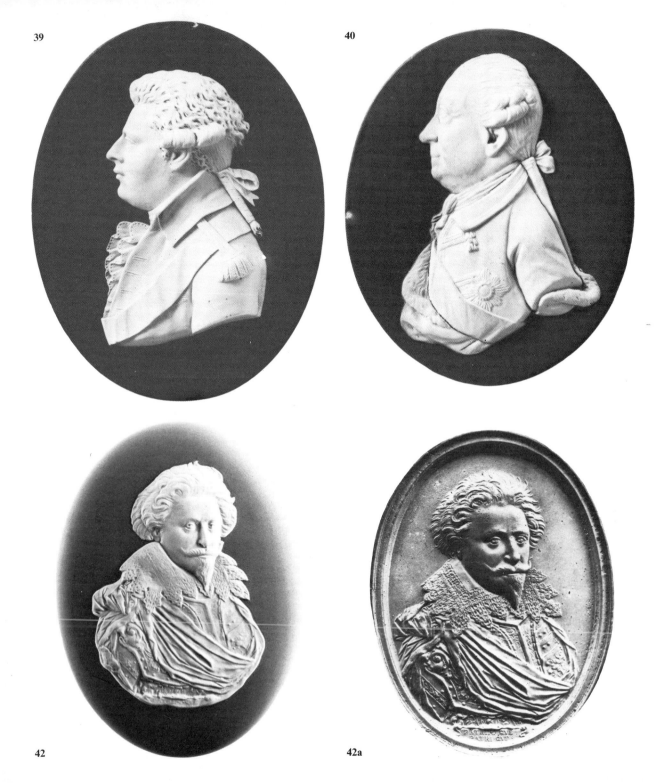

39

40

42

42a

43. FREDERICK WILLIAM II, 1744–97
King of Prussia. Nephew of Frederick the Great, whom he
succeeded in 1786. Invaded Holland, 1787, and restored
Stadholder; declared war on France, 1792, in support of French
Royal Family, but compelled by Treaty of Basel, 1795, to cede
territories west of the Rhine. Patron of Mozart and Beethoven.
Green dip. $3\frac{3}{4}$ in. WEDGWOOD
Modelled from a drawing 'supplied by Mr. Poggi' (possibly
Antonio Poggi), 1789
Wedgwood Museum, Barlaston

44. David GARRICK, 1717–79
Actor. Pupil of Samuel Johnson and accompanied him to
London, 1736. His first professional appearance as an actor,
1741, swiftly followed by London début as Richard III,
establishing his reputation. Co-manager, Drury Lane Theatre,
1747. One of the greatest actors in British stage history.
Blue jasper dipped dark blue. $2\frac{1}{8}$ in. WEDGWOOD & BENTLEY
Modelled by William Hackwood from the cast of a medal by
Thomas Pingo dated 1772
Wedgwood Museum, Barlaston

45. GEORGE III, 1738–1820
King of Great Britain and Ireland; Elector (1760–1815) and
King (1815–20) of Hannover. Grandson of George II, whom he
succeeded in 1760. Suffered, from 1765, from recurrent mental
disorders; became blind and finally deranged, 1811. His long
reign particularly notable for Napoleonic Wars in Europe and
loss of American colonies.
Blue dip. $3\frac{1}{2}$ in. WEDGWOOD
Re-modelled by William Hackwood, 1776, from his earlier model
adapted from a wax portrait by Isaac Gosset
Wedgwood Museum, Barlaston

46. GEORGE IV, 1762–1830
King of Great Britain and Ireland. Eldest son of George III.
Contracted morganatic marriage with Mrs. Fitzherbert, 1782,
but obliged to marry Princess Caroline of Brunswick, 1795.
Regent from 1810, during the final period of his father's
derangement. Acceded as King, 1820. Built Brighton Pavilion
and Carlton House.
Pale blue jasper, dipped darker blue. $3\frac{11}{16}$ in. WEDGWOOD
Modelled by J. C. Lochée about 1787
Nottingham Museum & Art Gallery

47. Edward GIBBON, 1737–94
Historian. Educated at Westminster, Magdalen College, Oxford
(where he spent fourteen 'unprofitable months') and Lausanne.
Professor in Ancient History at the Royal Academy;
Commissioner of Trade and Plantations, 1779–82. Published
numerous works of history and criticism. His *Decline and Fall
of the Roman Empire* published 1776–88.
Solid pale blue jasper. $2\frac{15}{16}$ in. WEDGWOOD
Probably modelled from the portrait by Sir Joshua Reynolds,
1779, or an engraving of this portrait
Victoria & Albert Museum

48. Johann Wolfgang von GOETHE, 1749–1832
German poet and dramatist. Educated at Leipzig; studied law at
Strasbourg. With his first tragedy *Götz von Berlichingen*, 1773,
established Shakespearian form of drama on German stage.
His dramatic works and poetry exercised dominant influence on
German literature. *Die Leiden des jungen Werthers*, 1774,
inspired certain of Wedgwood's jasper relief decorations.
Green dip. 4 in. WEDGWOOD
Attributed to John Flaxman Jnr.
Wedgwood Museum, Barlaston

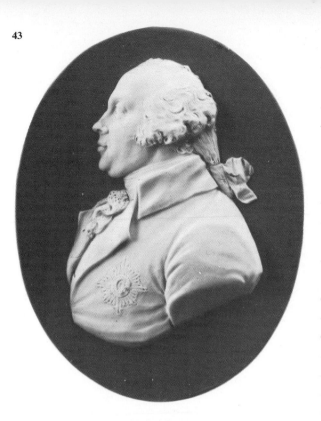

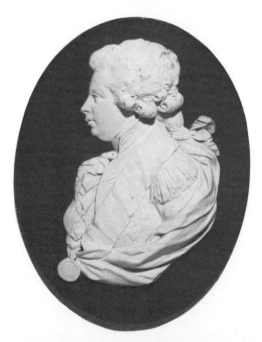

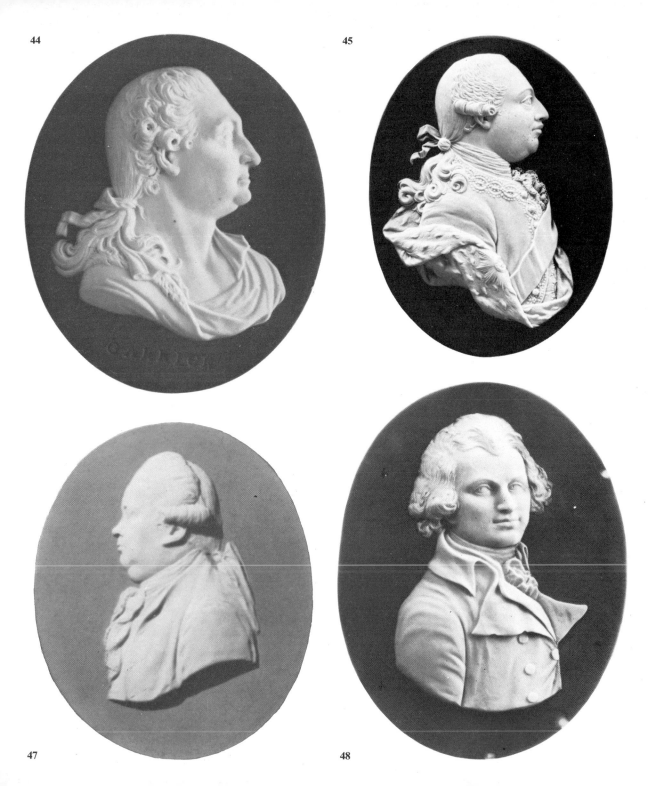

44

45

47

48

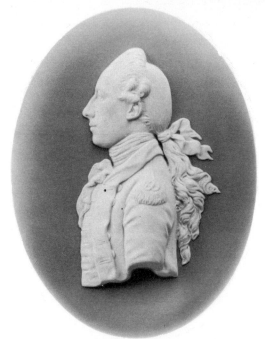

49. Captain Edward HAMILTON, fl. *c*.1750–80
Described for many years simply as 'Captain Hamilton', this
subject is now identified from a portrait by Pompeo Batoni.
Edward Hamilton served in the army for nine years (1765–74),
being promoted but once. He accompanied Sir Watkin Williams-
Wynn on the Grand Tour but appears to have no other claim
to distinction.
Solid pale blue jasper. 5 in. WEDGWOOD MADE IN ENGLAND.
(Reproduction made in 1972)
Attributed to Joachim Smith about 1774–75
Wedgwood Museum, Barlaston

50. Sir William HAMILTON, 1730–1803
Diplomat and archaeologist. Plenipotentiary at Naples,
1764–1800. Married, 1791, Emma Lyon, who became Nelson's
mistress. Made numerous ascents of Vesuvius, witnessing
eruptions of 1776 and 1777, and compiled account of excavations
at Pompeii. Purchased 'Warwick Vase' and, from James Byres,
the 'Barberini Vase' which he sold to the Duke of Portland.
Friend and patron of Josiah Wedgwood whose classical designs
owed much to his influence.
Biscuit. $6\frac{7}{16}$ in. Unmarked
Modelled by Joachim Smith, 1772
British Museum

51. Jonas HANWAY, 1712–86
Traveller and philanthropist. Travelled, precariously, in Russia
and Persia, 1743–45. Settled in London and published account
of his travels, 1753. One of the founders of Marine Society, 1756,
and the Magdalen Charity, 1758; a reformer of the Foundling
Hospital and pioneer of the umbrella. Monument by J. F.
Moore in Westminster Abbey.
Blue dip. $4\frac{1}{4}$ in. WEDGWOOD
Modelled about 1780/81 from an engraving after the portrait by
T. Orde
Wedgwood Museum, Barlaston

52. George Augustus Eliott, 1st Baron HEATHFIELD, 1717–90
General. Served as volunteer in the Prussian army, 1735–36, and
present with British army at Dettingen, 1743, and Fontenoy,
1745. Commander-in-Chief of forces in Ireland, 1774–75;
Governor of Gibraltar, 1775; defended Gibraltar against D'Arzon
and the Spanish, 1779–83. Created Baron Heathfield of
Gibraltar, 1787.
Green dip. 4 in. WEDGWOOD
Probably adapted from a drawing by G. F. Koehler, *c*.1785
British Museum

53. Sir William HERSCHEL, 1738–1822
Astronomer. Born in Hannover; sent secretly to England, 1757.
Organist at Halifax, 1765 and Octagon Chapel, Bath, 1766.
Constructed optical instruments, 1773, and began observation of
stars. Discovered Uranus (shown in orbit on the field of the
medallion), 1781; Fellow of the Royal Society, 1781; first
President Astronomical Society. Discovered Enceladus and
Mimas, 1789, and altogether more than two thousand nebulae;
investigated rotation of Mars; discovered infra-red solar rays,
1800. Knighted, 1816.
Green dip. 4 in. WEDGWOOD
Attributed to John Charles Lochée, about 1785
Wedgwood Museum, Barlaston

54. HERSCHEL
Pale blue jasper dipped paler blue. $4\frac{3}{4}$ in. WEDGWOOD
Usually attributed to John Flaxman Jnr., about 1788
Wedgwood Museum, Barlaston

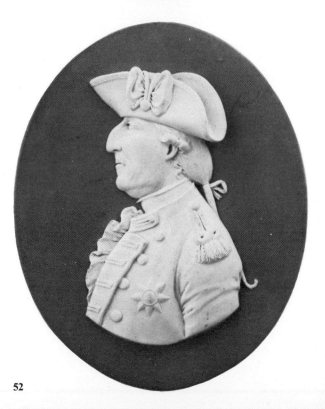

55. Richard, Earl HOWE, 1726–99
Admiral. Sailed with Anson to Cape Horn, 1740; captured
Alcide off mouth of St. Lawrence, 1755, opening the Seven
Years' War. Distinguished himself in Rochefort expedition,
1757, blockade of Brest, and battle of Quiberon Bay, 1759.
Commander-in-Chief North American station, 1777–78.
Relieved Gibraltar, 1782; commanded Channel Fleet in victory
of 'Glorious 1st of June', 1794, over French. Responsible for
perfecting naval signals code.
Lilac dip. 3⅞ in. WEDGWOOD
Modelled by John de Vaere, 1798
British Museum

56. JOSEPH II, 1741–90
Holy Roman Emperor, 1765–90. Son of Francis I and Maria
Theresa. Co-regent of Austria and ruler of Bohemia and Hungary
after his mother's death, 1780. Suppressed convents and reduced
clergy, but published, 1781, Edict of Toleration. Generally
regarded as one of Europe's benevolent despots.
Green dip. 4½ in. WEDGWOOD
Modelled from an engraving by Jacob Adam, Vienna, 1783.
First produced about 1786
Wedgwood Museum, Barlaston

57. John Philip KEMBLE, 1757–1823
Actor. Son of actor-manager, Roger Kemble, and brother of
Sarah Siddons. Educated for the priesthood but pursued a career
on the stage from 1776. Appeared in Edinburgh and Dublin, and
at Drury Lane, 1783–1802. Manager Drury Lane from 1788,
and Covent Garden 1803–8. Retired 1817.
Green dip. 4½ in. WEDGWOOD
Attributed to John Flaxman Jnr. about 1784
Wedgwood Museum, Barlaston

58. Augustus, 1st Viscount KEPPEL, 1725–86
Admiral. Accompanied Anson on his voyage round the world,
1740; commanded North American station, 1754; Commander-
in-Chief Grand Fleet, 1778. Court-martialled, 1779, for conduct
in operations off Brest, but honourably acquitted and became
a public hero. Created Viscount Keppel, 1782.
Chocolate-brown dip. 4 in. Wedgwood & Bentley
First produced on 13th March 1779, only twelve days after
Wedgwood had written to Bentley complaining that he had no
model to work from
Private Collection

59. Egbert Meeuwszoon van KORTENAER, d.1665
Dutch admiral, who rose from the lowest ranks to lieutenant-
admiral. Took over command of Dutch fleet at battle of Heyde,
1653, when the admiral was killed. Distinguished himself in war
against Sweden, 1658; appointed Vice-Admiral, 1659. Killed at
battle of Lowestoft, 1665.
Solid pale blue jasper. 3½ in. WEDGWOOD
Attributed to John Flaxman Jnr., about 1782
Wedgwood Museum, Barlaston

**60. Marie Joseph Paul Roch Yves Gilbert Motier, Marquis de
LAFAYETTE, 1757–1834**
French statesman and soldier. Entered French army 1771 but
withdrew, 1776, to join American service in revolutionary war.
Commissioned as major-general by Congress; intimate friend of
George Washington. Returned to France; member of National
Assembly, 1789, but declared traitor and fled to Flanders;
Member of Chamber of Deputies; leader of opposition 1825–30.
Blue dip. 1⅞ in. WEDGWOOD
A rare portrait first produced about 1790 in two sizes, the
smaller of which was used to decorate scent bottles
Reilly Collection

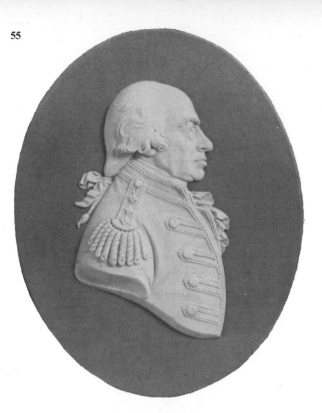

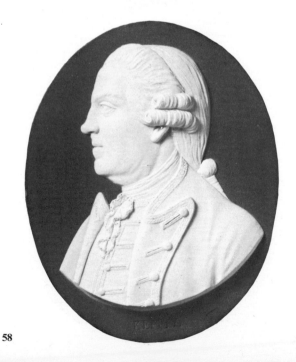

58

56

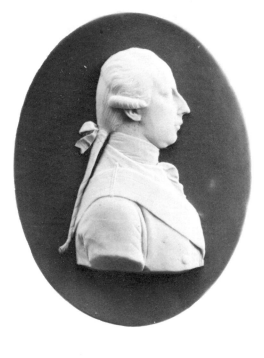

57

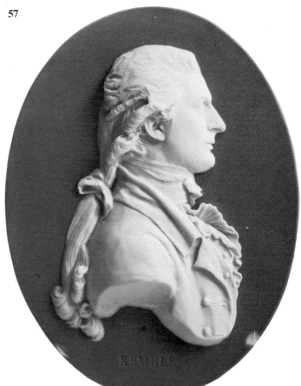

KEMBLE

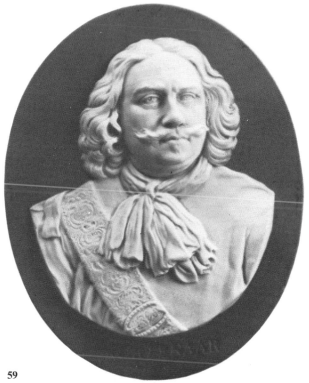

59

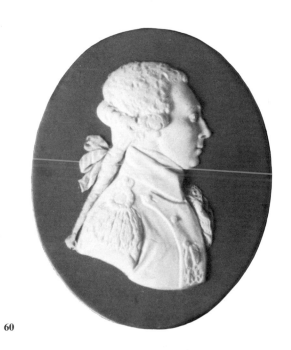

60

61. Jean de LA FONTAINE, 1621–95
French poet and fabulist. Published twelve volumes of fables,
1668–94, dedicated variously to the Dauphin, Madame de
Montespan, and the duc de Bourgogne. Author of *Contes* and
Fables, 1664–94; poetry; opera libretti; and plays. Friend of
Racine, Molière, and Boileau.
Blue dip. 2¼ in. WEDGWOOD
Probably modelled from a medal by Pesez, about 1776
Wedgwood Museum, Barlaston

62. Carl von LINNÉ (LINNAEUS), 1707–78
Swedish botanist, regarded as father of modern systematic
botany. Son of Lutheran pastor; educated at Lund and Uppsala.
Published numerous works on botanical subjects. Explored
Lapland; visited Holland, France, and England.
Yellow-buff relief on white jasper. 3¼ in. WEDGWOOD & BENTLEY
Trial piece. Scratch-marked with formula '1M/2C/1 pitcher slip/
1 dish no flint in/ Ground 1559'
Adapted, 1775, from the cast of a medal and a wax portrait by
Inlander
Wedgwood Museum, Barlaston

63. LOUIS XIV, 1638–1715
King of France ('Le Roi Soleil'). Son of Louis XIII and Anne of
Austria. Acceded to throne at age of five under regency controlled
by Mazarin. Assumed power, 1661; engaged in wars with Spain,
Netherlands, and Britain concluded at Utrecht, 1713. His reign
marked by the golden age of arts and letters in France.
Ivory carving by Michel Mollart (*d*.1713). 4¹⁄₁₆ in.
A mould of an identical portrait exists at Barlaston, indicating
that it was copied by Wedgwood, but no basaltes or jasper
example of the medallion has been traced
Victoria & Albert Museum

64. LOUIS XVI, 1754–93
King of France. Grandson of Louis XV, whom he succeeded,
1774; married, 1770, Marie Antoinette. At first aided by able
ministers, and instituted reforms of objectionable laws and taxes,
but later failed to resist extravagances of the Queen and Court.
Brought to Paris by revolutionaries, 1789; tried for treason,
1792; guillotined, 1793.
Blue dip. 3 in. WEDGWOOD
Modelled by William Hackwood, 1778, from a medallion by
Renaud
Wedgwood Museum, Barlaston

65. Charles MACKLIN, 1697(?)–1797
Actor and stage-manager. Appeared at Drury Lane, 1733–48;
celebrated for interpretation of Shylock in *Merchant of Venice*;
with Sheridan in Dublin for ten years between 1748 and 1770;
at Covent Garden for fourteen years.
Solid blue jasper. 3½ in. WEDGWOOD
Modelled by John Charles Lochée in 1784
Wedgwood Museum, Barlaston

66. MARIA I, 1734–1816
Queen of Portugal, 1777–1816. Eldest daughter of King Joseph
Emanuel; married, 1760, her uncle, Pedro. Always feeble and
weak-minded, she became demented after her husband's death
in 1786, and the government was taken over by her second son,
John, who was declared regent in 1799.
Black dip. 3⁷⁄₈ in. WEDGWOOD
Modelled by John Flaxman Jnr., 1787. His wax portrait was sent
to Etruria in June, and the portrait was in production before the
end of that year
British Museum

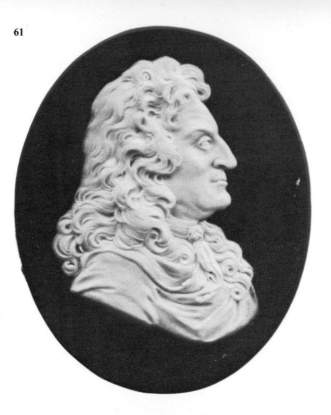

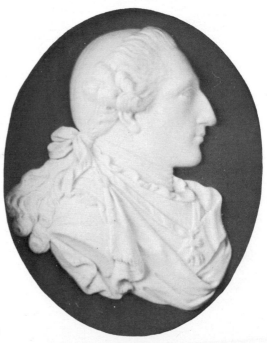

64

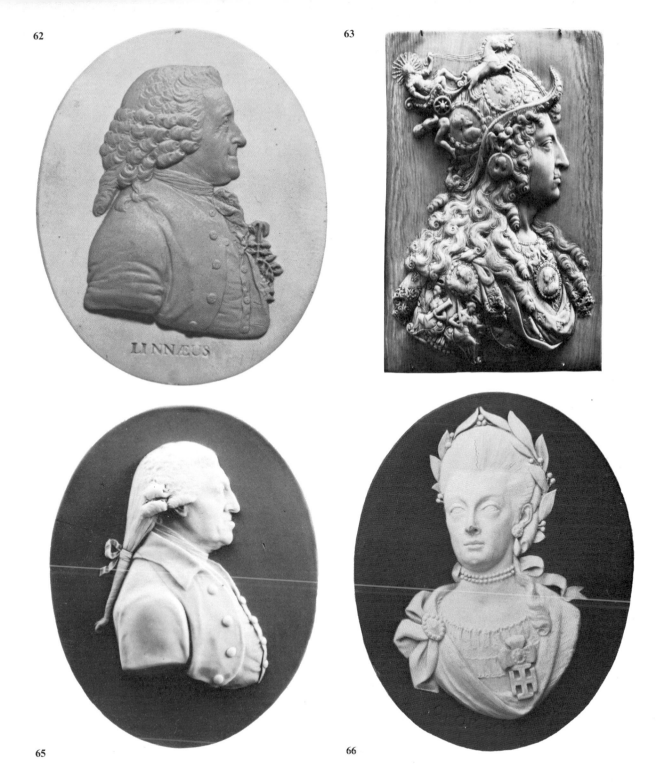

62

63

LINNÆUS

65

66

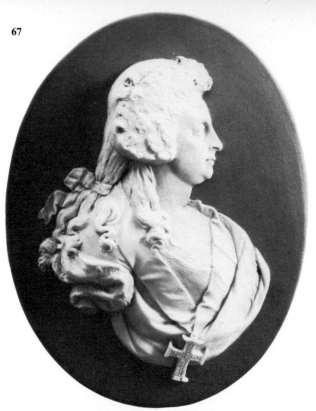

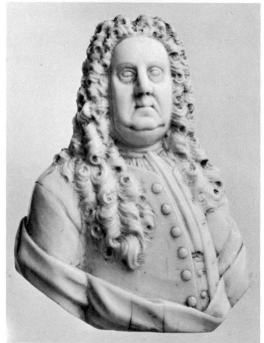

67. MARIA I
Black dip. 4 in. WEDGWOOD
A second portrait, also produced about 1787, attributed to John
Charles Lochée
Wedgwood Museum, Barlaston

68. MARIE ANTOINETTE, 1755–93
Queen of France. Daughter of Francis I and Maria Theresa;
married, 1770, French Dauphin, later Louis XVI. Her
extravagance and love of luxury made her the object of loathing
and contempt in France. Influenced Louis to attempt flight from
France, 1791; tried to obtain aid from her brother, Joseph II.
Found guilty of treason by revolutionary tribunal; guillotined,
1793.
Blue dip. 3 in. WEDGWOOD
From a medallion by Jean Baptiste Nini, 1774. First produced
about 1784
Wedgwood Museum, Barlaston

69. Richard MEAD, 1673–1754
Physician. Educated at Utrecht and Leiden; M.D. Padua, 1695;
published a treatise on venomous snakes, 1702; Fellow of the
Royal Society, 1703; physician to St. Thomas's Hospital, 1703–
15; physician to George I, George II, Sir Isaac Newton, and
Sir Robert Walpole.
Solid grey-blue jasper. $3\frac{3}{8}$ in. (Maximum relief measurement
$2\frac{11}{16}$ in.)
Modelled from a cast of Bevan's ivory carving (**69a**) sent to
Etruria by Samuel More, 1778
British Museum

69a. Carved ivory portrait by Silvanus Bevan (1691–1765)
$3\frac{7}{16}$ in. (Maximum measurement of ivory relief without
background)
British Museum

69b. Wax portrait (maximum measurement of wax relief without
background $2\frac{7}{8}$ in.). Inscribed J. FLAXMAN on truncation.
Probably an intermediate portrait, based on the Bevan ivory, and
showing alterations necessary to its production in jasper. The
authenticity of the Flaxman inscription is open to doubt
British Museum

69c. Wedgwood plaster mould. (Not illustrated)
Wedgwood Museum, Barlaston

70. MOLIÈRE, 1622–73
Pseudonym of Jean-Baptiste Poquelin, French playwright and
actor. Formed his own company of players performing in Paris
and provinces from 1643; gained patronage of French Court;
his first successful comedy *Les Précieuses Ridicules*, 1659,
followed by many outstanding comedies establishing his
reputation as leading French comic dramatist
Dark blue dip. $2\frac{1}{4}$ in. WEDGWOOD
Modelled from a medal by Pesez, about 1776
Wedgwood Museum, Barlaston

69a

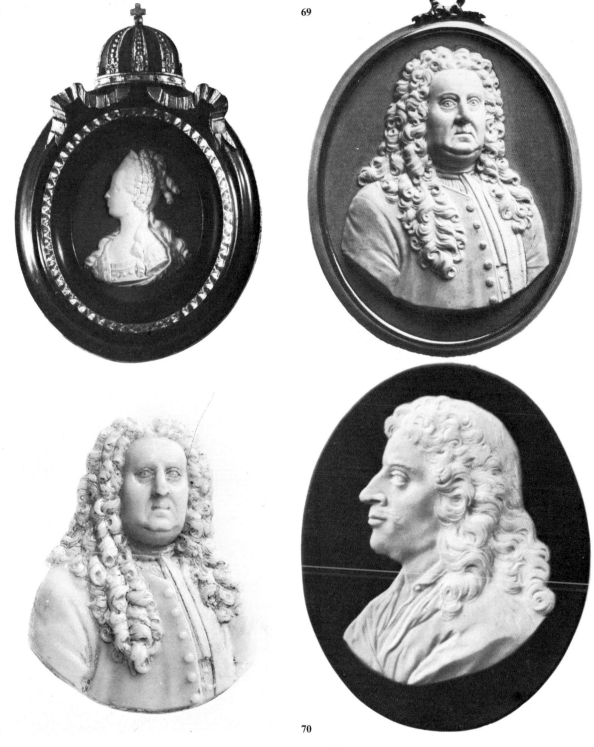

68

69

69b

70

71. Elizabeth MONTAGU, 1720–1800
Born Elizabeth Robinson; married Edward Montagu, grandson
of Earl of Sandwich, 1742; sought to make her house the centre
of fashion and intellect in London, attracting to herself the
epithet 'blue-stocking'. After her husband's death, built
Montagu House, designed by James ('Athenian') Stuart. Wrote
essays and many letters, the latter published in four volumes,
1809–13.
Blue dip. 2¾ in. Wedgwood & Bentley
First produced in 1775
Wedgwood Museum, Barlaston

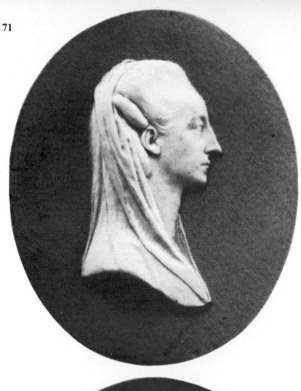

72. Charles de Secondat, Baron de MONTESQUIEU, 1689–1755
French lawyer, political philosopher and man of letters.
President of Bordeaux *parlement*, withdrew from law practice to
become a writer. Celebrated particularly for *Lettres Persanes*,
1721, satirizing French society, and *L'Esprit des Lois* in thirty-one
books, 1748, one of the most influential works of the
eighteenth century.
Blue dip. 2¼ in. WEDGWOOD
Adapted from a medal by J. A. Dassier, dated 1753. First listed
1773
Wedgwood Museum, Barlaston

73. NAPOLEON I (Bonaparte), 1769–1821
Emperor of the French. Born Ajaccio, Corsica; married Joséphine
de Beauharnais, 1796, and secondly, Archduchess Maria Luisa
of Austria, 1810. By conquest or diplomatic pressure, secured
control of greater part of Europe; invaded Russia, 1812, but
repulsed with appalling losses. Defeated and exiled to Elba, 1814;
escaped, and finally defeated at Waterloo, 1815; exiled to
St. Helena. First Consul of France, 1796; Emperor, 1805.
Dark blue dip. 2⅞ in. WEDGWOOD
Probably produced during the period of Napoleon's Consulate,
1796–1805
British Museum

74. Horatio, Viscount NELSON, 1758–1805
Vice-admiral. Joined Royal Navy, 1770; served in West Indies;
lost sight in his right eye at Calvi, 1794; met Emma Hamilton
at court of Naples, 1793; present at Cape St. Vincent, and lost
right arm at Santa Cruz, 1797; Knight of the Bath, 1797;
Viscount, 1801; second-in-command at Copenhagen; killed at
Trafalgar, 1805.
Blue dip. 4 in. WEDGWOOD
Modelled by John de Vaere in 1798
Wedgwood Museum, Barlaston

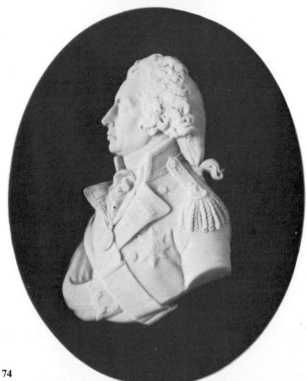

75. Sir Isaac NEWTON, 1642–1727
Natural philosopher. Discovered the binomial theorem,
differential calculus, integral calculus, many of the properties of
light, and the law of universal gravitation. His *Principia
Mathematica* published 1687, and *Optics* in 1704. Elected
President of the Royal Society, 1703, and re-elected each year
until his death. Knighted by Queen Anne, 1705.
Black basaltes with moulded basaltes frame. 8 in. Unmarked
Modelled from an ivory medallion by David Le Marchand
(1674–1726) which may have been based on Kneller's portrait (**75a**)
Lady Lever Art Gallery, Port Sunlight

75a. Portrait by Sir Godfrey Kneller, 1702.
29¾ × 24½ in. Signed
Originally in the possession of Catherine Conduitt whose
daughter, Catherine, was also the subject of a Wedgwood
portrait medallion
National Portrait Gallery, London

74

72

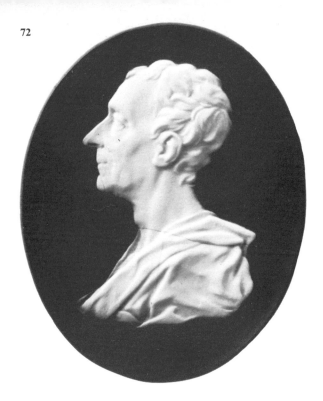

73

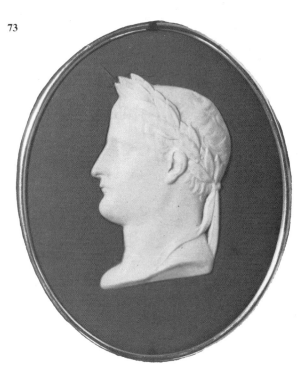

75

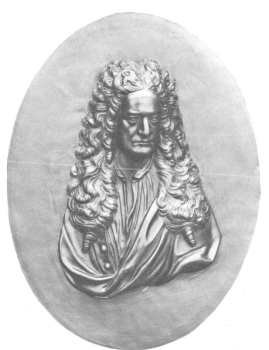

75a

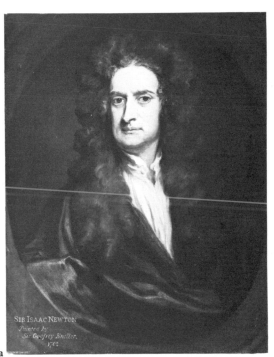

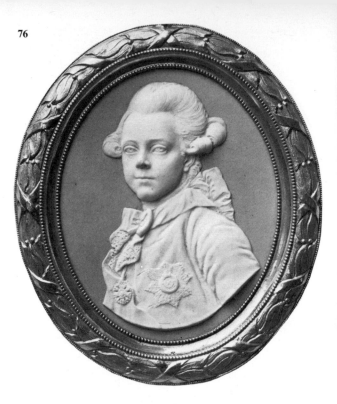

76. PAUL I, 1754–1801
Emperor of Russia. Son of Peter III and Catherine the Great.
Succeeded Catherine, 1796. Ruled despotically but attempted
reforms in treatment of serfs. Joined second coalition against
France, 1798, but participated in northern maritime league
against Britain, 1800–1. Assassinated, 1801.
Blue dip. $3\frac{7}{16}$ in. (Maximum relief measurement $2\frac{7}{8}$ in.).
WEDGWOOD. Modelled by John Flaxman Jnr.
British Museum

76a. Wax portrait modelled by John Flaxman Jnr., 1782,
probably from an engraving. Maximum relief measurement
$3\frac{7}{8}$ in.
Reilly Collection

77. PETER I ('The Great'), 1672–1725
Emperor of Russia. Reigned jointly with his half-brother, Ivan,
until the latter's death in 1689. Engaged in long war with
Sweden, 1700–21, culminating in peace of Nystadt, by which he
acquired great territories. Travelled extensively, spending three
months in England in 1698, and brought Western culture to
Russia.
Black basaltes. 15 in. WEDGWOOD & BENTLEY
One of the largest medallions produced by Wedgwood and first
listed 1773. Probably adapted from a medal by Duvivier
Wedgwood Museum, Barlaston

78. William PHILLIPS, 1731(?)–81
Major-general. Distinguished in command of artillery at
Minden, 1759, and Warburg, 1760; served in Canada under
Carleton and Burgoyne, 1776. Captured at capitulation at
Saratoga but exchanged as a prisoner of war, 1781. Died during
campaign in Virginia.
Blue dip. $3\frac{7}{16}$ in. WEDGWOOD
First produced in 1782
British Museum

79. William PITT ('The Younger'), 1759–1806
Statesman. Second son of 1st Earl of Chatham. Member of
Parliament, 1781; Chancellor of the Exchequer, 1782; Prime
Minister in his twenty-fifth year, 1783; subsidized European
coalitions against France during Napoleonic Wars; resigned,
1801; but returned to office, 1803. Formed Third Coalition,
shattered by defeat at Austerlitz, 1805, and died in January 1806.
Blue dip. $3\frac{5}{8}$ in. WEDGWOOD
Attributed to John Flaxman Jnr., about 1787
Wedgwood Museum, Barlaston

80. Joseph PRIESTLEY, 1733–1804
Theologian and chemist. Studied for Presbyterian ministry.
Minister, tutor in belles-lettres, lecturer on anatomy, astronomy,
and modern history. Fellow of the Royal Society, 1776;
Associate French Academy of Sciences; member of Imperial
Academy of Sciences, St. Petersburg, 1780. First to obtain
'dephlogisticated air' (oxygen). Described as 'the father of modern
Chemistry'.
Dark blue dip. $5\frac{1}{2}$ in. WEDGWOOD
Attributed to William Hackwood, about 1779
Wedgwood Museum, Barlaston

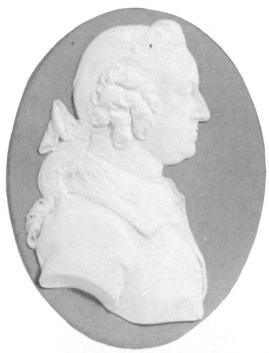

76a

77

79

80

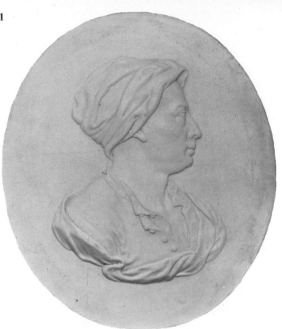

81. Matthew PRIOR, 1664–1721
Poet and diplomat. Educated at Westminster School and St.
John's College, Cambridge. Member of Parliament, 1701;
negotiator for the Peace of Utrecht, 1713. His poems,
published in 1719, were greatly acclaimed and include 'The Town
and Country Mouse'.
Polished biscuit. $3\frac{11}{16}$ in. Unmarked
Apparently copied from the wax portrait (**81a**), c.1773–74
Reilly Collection

81a. Relief portrait in cream wax. $3\frac{1}{2}$ in. *diameter*. Artist
unknown
The style of this portrait closely resembles that of the medal of
Sir Hans Sloane by J. A. Dassier. (*Medallic Illustrations*
Pl.CLXIV.2)
Victoria & Albert Museum

82. John RAY, 1627–1705
Naturalist. Fellow of Trinity College, Cambridge; junior dean,
1658. Compiled, with Francis Willughby, systematic description
of plants and animals, published 1670 and 1682. His *Historia
Plantarum* (1686–1704) gained him the title, 'the father of natural
history'.
Pale blue dip. $3\frac{7}{16}$ in. WEDGWOOD
Attributed to Flaxman, and copied from a fine medal, probably
by G. D. Gaab, struck to commemorate Ray's death in 1705
Nottingham Museum & Art Gallery

83. Sir Joshua REYNOLDS, 1723–92
Portrait painter. Apprenticed to Thomas Hudson; studied in
Italy; returned to London, 1743, where he became the leading
portrait painter of his age, earning as much as £6,000 a year.
First President of Royal Academy, 1768; knighted, 1769.
Advised Wedgwood on the employment of artists, and approved
his reproduction of Portland Vase.
Pale blue dip. $3\frac{1}{4}$ in. WEDGWOOD
Attributed to John Flaxman Jnr., who was also responsible for
the monument to Reynolds in St. Paul's Cathedral
Nottingham Museum & Art Gallery

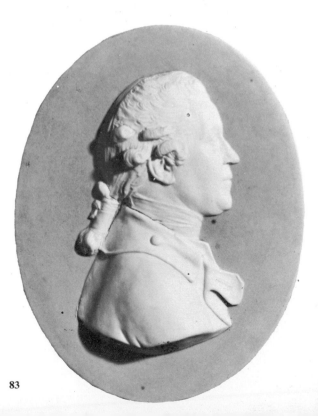

84. Sir John Jervis, 1st Earl of ST. VINCENT, 1735–1823
Admiral. Entered navy, 1749; rose from rank of able seaman;
distinguished in many naval actions including Quebec, Ushant,
and three reliefs of Gibraltar. 1780–82; K.B., 1782; commanded
Mediterranean fleet, 1797; defeated Spanish fleet off Cape St.
Vincent; created Earl, First Lord of the Admiralty, 1801–4;
Commander-in-Chief Channel Fleet, 1806–7; Admiral of
the Fleet, 1821.
Basaltes. $3\frac{3}{4}$ in. WEDGWOOD
Modelled by John de Vaere in 1798
Reilly Collection

85. William SHAKESPEARE, 1564–1616
Dramatist and poet. Born at Stratford-on-Avon. Educated at free
Grammar School, 1571–77. Married Anne Hathaway, 1582.
Arrived in London, 1586, and employed in a theatre; joined
Earl of Leicester's theatrical company; wrote *Love's Labours Lost*,
c.1591, the first of his plays, published 1598. The first folio
edition of all his plays except *Pericles* was published in 1623.
Black basaltes. $4\frac{1}{2}$ in. Wedgwood & Bentley
Modelled by William Hackwood, from an engraving, in 1777
Wedgwood Museum, Barlaston

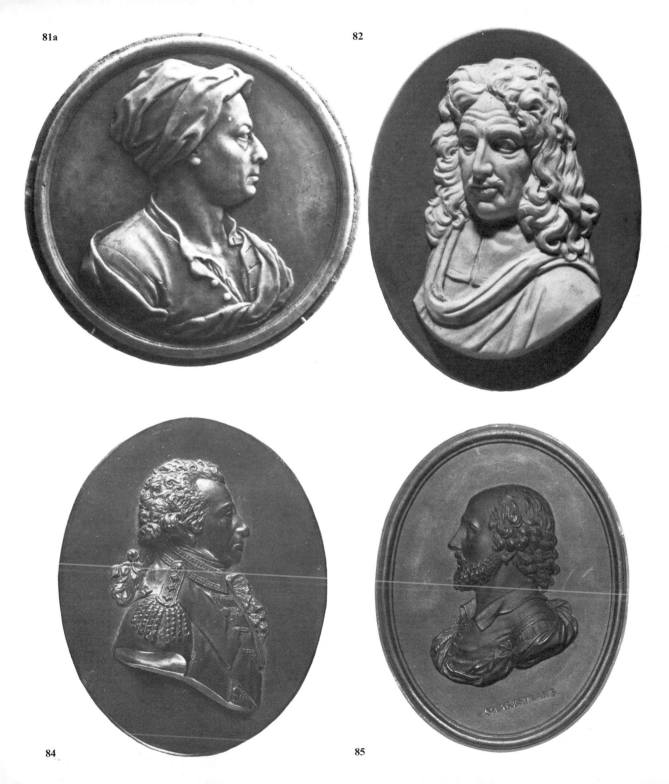

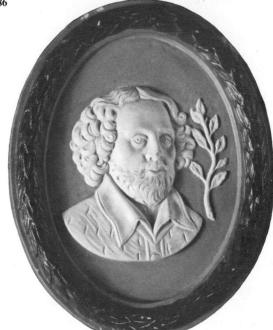

86. SHAKESPEARE
Polished biscuit. 3 in. Ground and reverse enamelled grey-blue;
moulded frame enamelled terra-cotta and black. A trial
medallion *c*.1774. Unmarked
Reilly Collection

87. Sarah SIDDONS, 1755–1831
Actress. Daughter of Roger Kemble and sister of John Philip
Kemble. Child actress with company formed by William Siddons,
whom she married, 1773. Engaged by Garrick at Drury Lane,
1755–56, but failed; several successes at Manchester, Bath, and
and Bristol and made triumphant return to Drury Lane, 1782.
Acted at Covent Garden, 1806–12
Dark blue dip. 5 in. WEDGWOOD
Attributed to John Flaxman, about 1782; believed to represent
Mrs. Siddons as Lady Macbeth
Wedgwood Museum, Barlaston

88. Sir Hans SLOANE, 1660–1753
Physician and collector. Fellow of the Royal Society, 1685;
President of the Royal College of Physicians; physician to Queen
Anne and George II; created baronet, 1716. Founded Botanic
Garden, 1721; published catalogue of Jamaica Plants and account
of voyages in West Indies. His collections purchased by the
nation, 1754.
Pale blue dip. $3\frac{7}{16}$ in. WEDGWOOD
Adapted from a cast of the ivory carving by Silvanus Bevan
(1691–1765), about 1778–79
Nottingham Museum & Art Gallery

89. Adam SMITH, 1723–90
Political economist. Studied at Glasgow University and Balliol
College, Oxford; returned to Glasgow and elected to Chair of
Logic, 1751; Chair of Moral Philosophy and Vice-Rector, 1752.
Visited Hume, Turgot and Voltaire. Published *The Wealth of
Nations*, 1776, originating study of political economy as separate
science.
Pale blue jasper dipped dark blue. $3\frac{1}{4}$ in. WEDGWOOD
Modelled by James Tassie in 1787
Wedgwood Museum, Barlaston

89a. Plaster cast from glass paste portrait by James Tassie.
Signed and dated 1787. $3\frac{3}{4}$ in.
Scottish National Portrait Gallery, Edinburgh

90. Daniel Charles SOLANDER, 1736–82
Botanist. Born in Sweden; introduced by Linnaeus to naturalists
in England to whom he introduced Linnean system. Accompanied
Joseph Banks on Cook's voyage, 1768, and to Iceland, 1772;
Keeper Natural History department, British Museum, 1773.
Pale blue jasper dipped darker blue. $3\frac{1}{4}$ in. Wedgwood & Bentley
Modelled by John Flaxman Jnr. in 1775
Wedgwood Museum, Barlaston

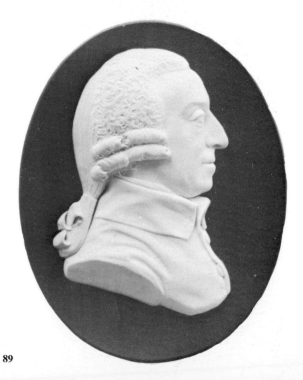

87

88

H. SLOANE

89a

90

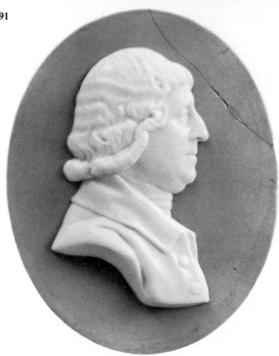

91. Granville Leveson-Gower, 1st Marquess of STAFFORD, 1721–1803
Succeeded his father as Earl Gower in 1754. Member of Parliament for Westminster; Lord of the Admiralty, 1749; Lord Privy Seal, 1755–57 and 1785–94; Lord Chamberlain, 1763–65; Lord President of the Council, 1767–69 and 1783–84.
Green dip. 3½ in. WEDGWOOD
Attributed to William Hackwood, about 1782
Wedgwood Museum, Barlaston

92. Maximilien de Béthune, duc de SULLY, 1560–1641
French statesman. Lifelong friend of Henri IV. Minister of Finance, 1597; grand-master of artillery; master of works. *De facto* sole minister of France. Greatly improved finances of France by reforms in collection of taxes. Created duc de Sully, 1606, and Marshal of France, 1634.
Solid blue jasper. 4½ in. WEDGWOOD & BENTLEY
Probably modelled from an engraving after the portrait by Rubens, *c.*1779
Wedgwood Museum, Barlaston

93. Cornelis TROMP, 1629–91
Dutch admiral. Son of Maarten Harpertszoon Tromp. Defeated by British fleet under Prince Rupert at Southwold Bay, 1665; won important victories against combined British and French fleets, June 7th and 14th, 1673, when he sailed up the Thames; lieutenant-admiral of United Provinces, 1676.
Solid blue jasper. 2¼ in. WEDGWOOD
First produced about 1790
Wedgwood Museum, Barlaston

94. Maarten Harpertszoon TROMP, 1597–1653
Dutch admiral. Joined navy, 1624; lieutenant-admiral, 1637. Gained two important victories against Spanish fleets, 1639. Fought series of engagements with British fleets, 1652–53, generally against heavy odds. Killed, 29th July 1653, in battle with British fleet under Monck.
Solid blue jasper. 2¼ in. Wedgwood
Adapted from a medal by O. Müller. First produced about 1790
Wedgwood Museum, Barlaston

95. VICTORIA, 1819–1901
Queen of Great Britain and Ireland (1837–1901). and (from 1876) Empress of India. Only daughter of George III's fourth son, Edward, Duke of Kent; succeeded her uncle, William IV; married, 1840, Prince Albert of Saxe-Coburg-Gotha. Venerated by her subjects as the apparently indestructible symbol of British greatness and Empire.
Solid pale blue jasper. 5 in. WEDGWOOD MADE IN ENGLAND. (Reproduction made in 1972.) First produced about 1837. probably to celebrate the coronation
Wedgwood Museum, Barlaston

96. Jean François Marie Arouet, known as VOLTAIRE, 1694–1778
French writer. Twice imprisoned in Bastille (1717–18) for scurrilous lampoons; exiled and lived in England, 1726–29; returned to France; visited the Court of Frederick the Great, 1750–53; spent the last years of his life in Switzerland. One of the great masters of satire, and a substantial historian, dramatist, and philosophical novelist.
Solid yellow-buff jasper. 3¼ in. Wedgwood & Bentley
Modelled by William Hackwood, about 1778
Wedgwood Museum, Barlaston

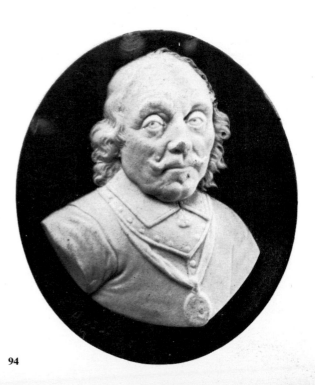

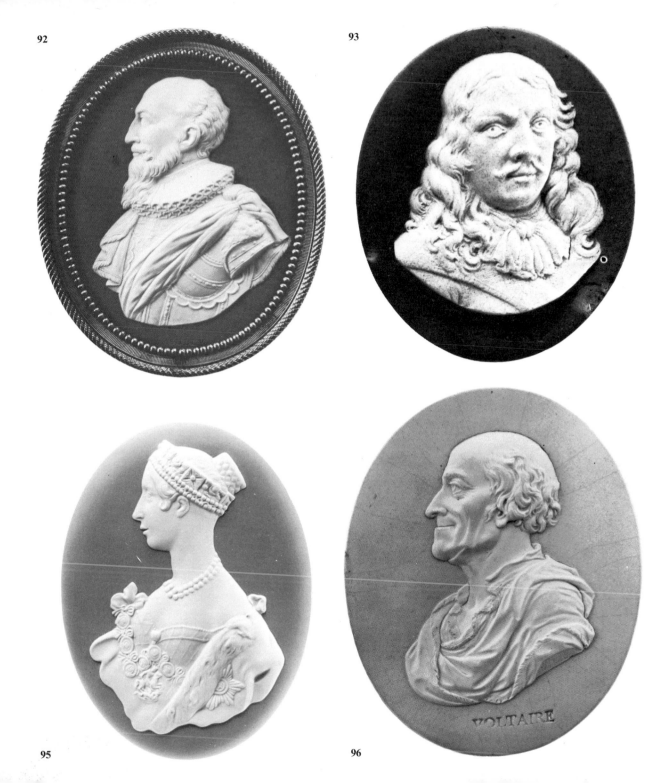

92

93

95

96

VOLTAIRE

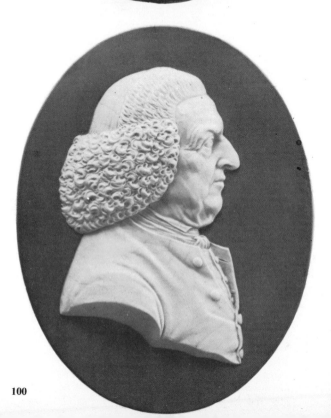

97. George WASHINGTON, 1732–99
First President of the United States. Born Westmoreland County,
Virginia. Served with British army against the French, 1754–58;
married Martha Custis, 1759; became one of the leaders of
Colonial opposition to Britain; commanded American army in
Revolution. Unanimously chosen President of United States
under new constitution, 1789; re-elected, 1793, and declined a
third term.
Blue dip. $2\frac{1}{2}$ in. WEDGWOOD
Modelled after an etching by J. Wright in 1789
British Museum

98. Josiah WEDGWOOD, 1730–95
Master-potter and founder of the Wedgwood pottery, 1759;
Fellow of the Royal Society, 1783.
Pale blue dip with rosso antico and basaltes frame.
$5\frac{1}{4}$ in. Unmarked
Modelled by William Hackwood in 1782
City Museum & Art Gallery, Stoke-on-Trent

99. John WESLEY, 1703–91
Evangelist and leader of Methodism. Scholar of Christ Church,
Oxford; ordained deacon, 1725; tutor at Lincoln College,
Oxford, 1729–35 and leader of his brother's 'methodist' society.
In charge of mission to Georgia, 1735. Much influenced by
Moravianism, but severed this connection to organize the
methodist movement. Published twenty-three collections of
hymns.
Dark blue dip. $3\frac{1}{8}$ in. WEDGWOOD
Manchester City Art Galleries

100. William WILLET, c.1698–1778
Unitarian minister at Newcastle-under-Lyme; married Josiah
Wedgwood's sister, Catherine. Through his interest in natural
philosophy he formed a lasting friendship with Joseph Priestley.
Green dip. 4 in. Unmarked
Modelled by William Hackwood in 1776. Of this portrait
Wedgwood wrote: 'A stronger likeness can scarcely be
conceiv'd.' Produced for private circulation among the family
Wedgwood Museum, Barlaston

101. WILLIAM V, 1748–1806
Stadholder of Holland, 1751–95. Married Frederica Wilhelmina
of Prussia. Weakened his country by participation in European
wars, and forced by revolution to flee to England. His son,
William, became first king of the Netherlands as William I.
Lilac dip. $3\frac{7}{16}$ in. WEDGWOOD
First produced about 1782
British Museum

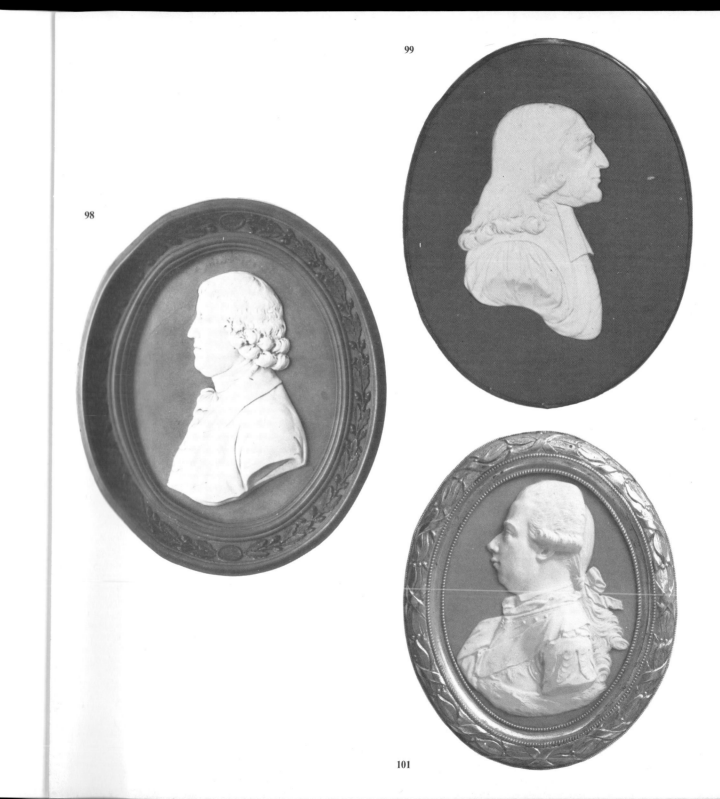

98

99

101

102. Sir Christopher WREN, 1632–1723

Architect. Fellow of All Souls College, Oxford, 1653–61;
Professor of Astronomy, Gresham College, London, 1657–61, and
Savilian Professor of Astronomy at Oxford, 1661–73. President
of the Royal Society, 1680–82. Surveyor-General to Charles II's
works, 1669. Prepared plans for rebuilding London after the
great fire, 1666. Member of Parliament, 1685. His buildings
included the Sheldonian Theatre, Oxford, St. Paul's Cathedral,
and fifty-two churches in London.
Blue dip. 5 in. WEDGWOOD
Modelled from the carved ivory portrait by David Le Marchand
(**102a**)
Lady Lever Art Gallery, Port Sunlight

102a. Carved ivory portrait by David Le Marchand
(1674–1726), *c*.1723
National Portrait Gallery, London

102

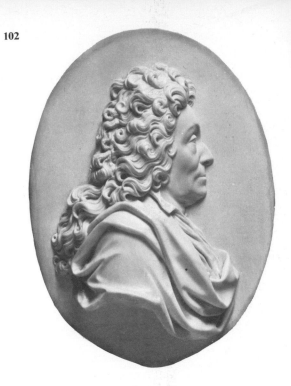

Published 1973 by
Barrie & Jenkins Ltd.,
24 Highbury Crescent,
London N5 1RX

Designed by Michael R. Carter

Printed and Bound by
Cox & Wyman Ltd
London, Fakenham and Reading

ISBN 0 214 66881 9

102a

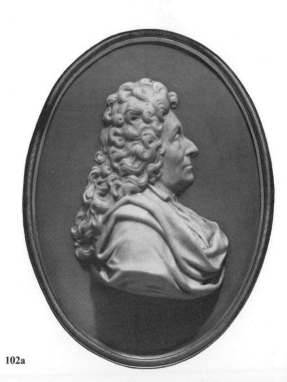

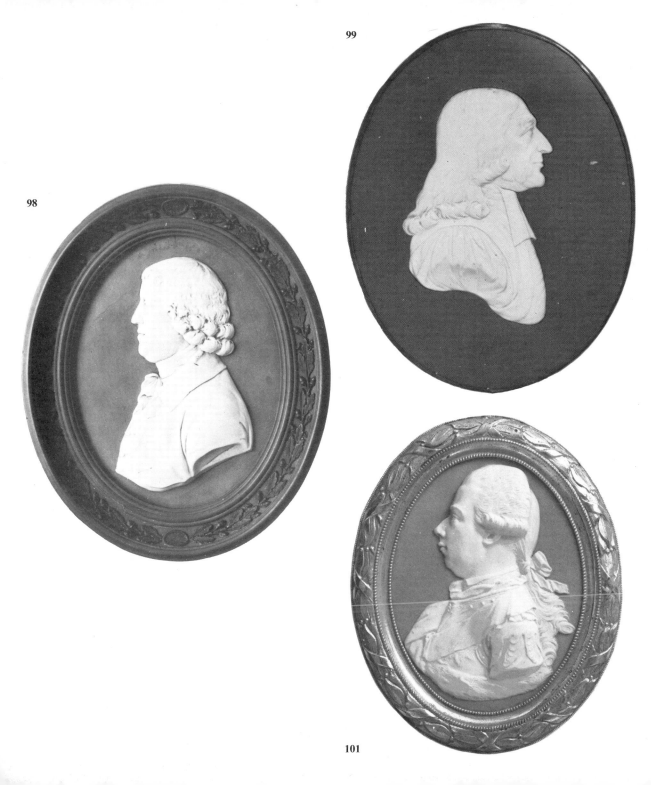

98

99

101

102. Sir Christopher WREN, 1632–1723
Architect. Fellow of All Souls College, Oxford, 1653–61;
Professor of Astronomy, Gresham College, London, 1657–61, and
Savilian Professor of Astronomy at Oxford, 1661–73. President
of the Royal Society, 1680–82. Surveyor-General to Charles II's
works, 1669. Prepared plans for rebuilding London after the
great fire, 1666. Member of Parliament, 1685. His buildings
included the Sheldonian Theatre, Oxford, St. Paul's Cathedral,
and fifty-two churches in London.
Blue dip. 5 in. WEDGWOOD
Modelled from the carved ivory portrait by David Le Marchand
(**102a**)
Lady Lever Art Gallery, Port Sunlight

102a. Carved ivory portrait by David Le Marchand
(1674–1726), *c.*1723
National Portrait Gallery, London

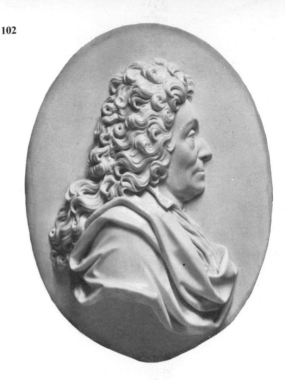

Published 1973 by
Barrie & Jenkins Ltd.,
24 Highbury Crescent,
London N5 1RX

Designed by Michael R. Carter

Printed and Bound by
Cox & Wyman Ltd
London, Fakenham and Reading

ISBN 0 214 66881 9

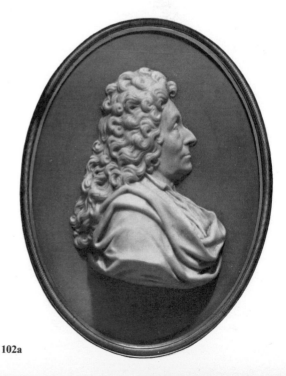

102a